TOGETHER WE RISE

Stories of Gratitude from Around the World

by:

LOOK FOR THE GOOD PROJECT

"When we deny our stories, they define us. When we own our stories, we get to write the ending."
- Dr. Brené Brown

Your Story Matters.

THIS BOOK WAS CREATED BY
THE LOOK FOR THE GOOD PROJECT

A public charity which improves school climate and empowers kids to become inspiring leaders in their communities. We create school programs and awareness campaigns around the core belief that gratitude changes mindsets, reduces violence, and improves everything.

RESEARCH SHOWS THAT GRATITUDE IS GOOD FOR YOUR HEALTH

It lowers blood pressure; It boosts your immune system; It creates favorable changes in the body's biochemistry including improved hormonal balance and increases in DHEA (the anti-aging hormone); It helps you sleep longer; It improves mental health; It decreases addictive tendencies and it makes you feel happy and at peace.

GRATITUDE IS GOOD FOR YOUR COMMUNITY

It improves your mood; It helps you communicate more effectively; It strengthens relationships; It increases your ability to deal with adversity, and it helps you connect with something larger than yourself.

GRATITUDE DECREASES VIOLENCE

According to researcher Evan M. Kleiman, positive traits like gratitude decrease the likelihood of suicide. Further studies show that grateful teens are significantly less likely to engage in bullying or violence.

LEARN MORE AT:

www.lookforthegoodproject.org

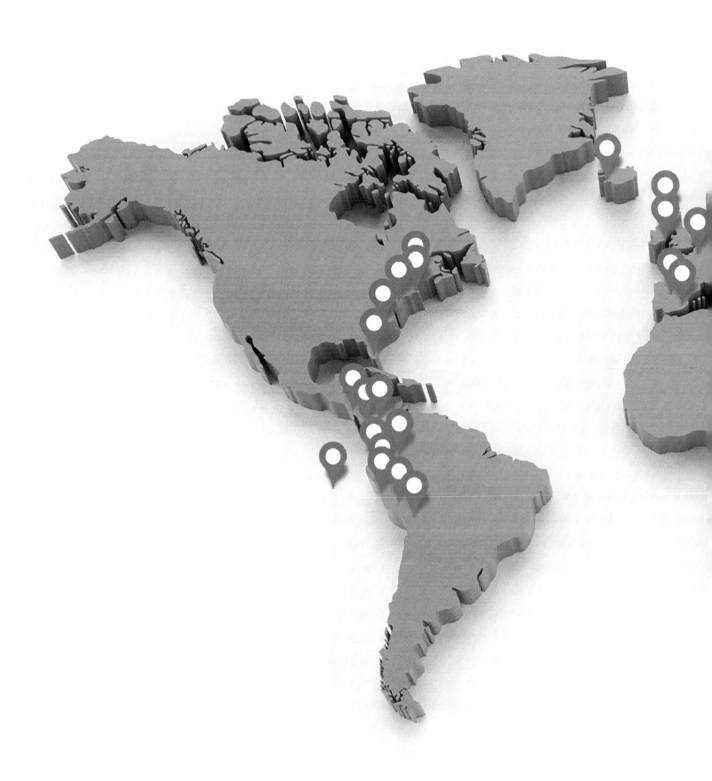

TWO YEARS, THIRTEEN COUNTRIES,

COUNTLESS VOLUNTEER HOURS, AND

"What Makes You Grateful?"

THREE-THOUSAND CONVERSATIONS, ONE SIMPLE QUESTION ON GRATITUDE.

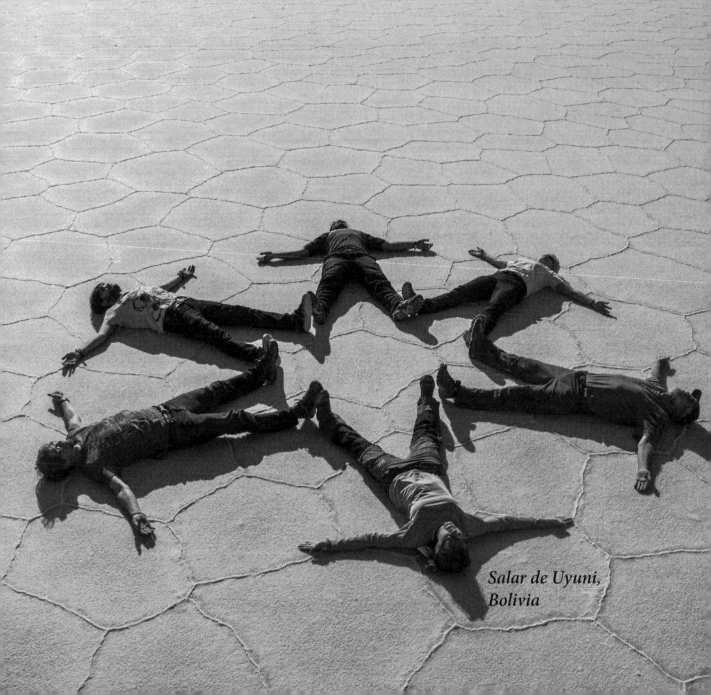

In Memory of Margaret Worthen, the inspiration behind the Look for the Good Hero Award. Her story is described on page 66.

Salar de Uyuni, Bolivia

FROM THE FOUNDER

Top: Anne
Kubitsky

Left: Dave
Lutian

I started the Look for the Good Project in 2011 because I wanted to be brave. I wanted to live against the grain, to dive into the vulnerability of my own story, and allow the mystery of life to lead. Along the way, many wonderful things happened: 164,000+ people participated in our awareness campaign; The project was featured on MSNBC and other national news; I published a number of books; I began working with schools, hospitals, and companies interested in improving their climate; And I received a variety of awards for my efforts to bring empathy back into society, including a national award originated out of the White House under former President George H. W. Bush. But running the Look for the Good Project has not been easy. It has tested my faith and rebooted my values. Most importantly, it's helped me see that nothing good can truly be accomplished alone. *We need each other.* And we should take the time to thank each other often. This book is dedicated to Dave Lutian who helped me look for the good when I almost gave up. Our story begins on the next page.

\- Anne Kubitsky
 Founder, Look for the Good Project

INTRODUCTION BY ANNE KUBITSKY

I met Dave in November, about three years after I started the Look for the Good Project. We were standing outside a church, shivering in our boots, as he painstakingly gave me directions. A few weeks later, he sat at my kitchen table, wide-eyed, as I poured out my soul, telling him all the reasons he should leave. Death, betrayal, rape, co-dependency – these were just a few things I was grappling with when I met Dave. Even though I barely knew him, the painful memories oozed out of me, making the air so thick I could hardly breathe. *"Why was he still here?"* I wondered. *"As the Founder of the Look for the Good Project, I'm supposed to embody gratitude and all I can talk about is what's wrong with me. Surely he'll never talk to me after this!"* Unphased, he returned smiling the next day, laden with food and a request to shovel my snowy driveway.

Our friendship quickly grew, and so did our conversations. Dave had just been offered a new job and asked for my advice. Even though I wanted him to stay, I encouraged him to follow his heart to Philadelphia for this new job opportunity. Dave left, and we continued to keep in touch. By March, our friendship had deep-ened and he told me he'd show up for me no matter what, even if it meant driving three hours out of his way simply to buy me groceries. *"You're family,"* he said as he paid the cashier.

Although I loved my job, I wasn't proud of the financial position I was in. The Look for the Good Project had recently reorganized into a nonprofit organization and my volunteers encouraged me to "have faith" in the promise of a modest salary, while in the meantime, I attempted to scrape by on a poverty-level stipend, working 80 hour weeks. I developed a school bullying prevention program; reworked the website; designed books; organized fundraising efforts; held board meetings; managed volunteers; traveled to schools; forged essential partnerships for the nonprofit; cobbled together a life in my temporary housing; and racked up the credit card. My parents lived just down the street and were offering free food and the use of their car, so I thought it was safe to bootstrap the nonprofit for just a little longer. But after three years of running on fumes to support the project, I was quickly losing my bearings as well as my motivation.

In April, the storm hit. My parents could

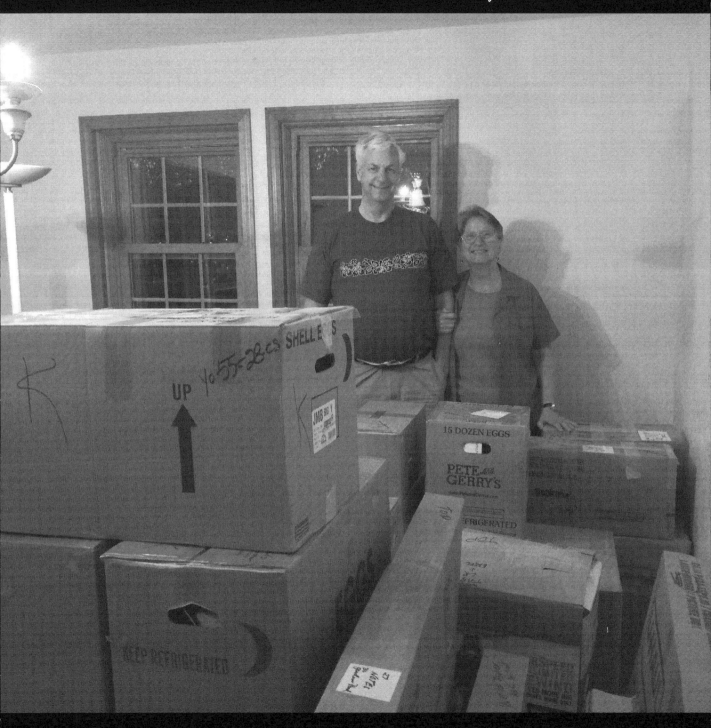

My parents in my childhood home.

no longer afford my childhood home and needed to relocate to another area of the country. They put the house up for sale and it sold within a week.

My birthday was spent amid a flurry of loud voices, clutter, and boxes. Pressured to downsize, my parents began throwing out photographs, heirlooms, and things that were important to me. In an attempt to salvage these things, I quickly found a studio in a rough neighborhood about an hour north. Dave called often and drove up every weekend, even getting his friends and family to help me relocate.

By June, Dave had transferred back to Connecticut to be closer to me, my parents had moved far away, and the stress of trying to keep myself afloat had crept into my body: A lump had formed and the doctor thought it was cancer. I found a surgeon; Dave paid for the procedure.

By October, the stress had crept into my mind and I was prescribed an anti-anxiety medication "just in case." Dave held my hand and let me cry on his shoulder. It was then that I suddenly remembered the location where I had been sexually assaulted as a teen. In my haste to move, I hadn't realized that I had relocated to the town of the crime, and had been driving by

the exact location twice a week since I got there. Dave held me while I sobbed. *"It's okay,"* he assured me.

In these precious, vulnerable moments where I allowed my pain to be seen, Dave chose to wholeheartedly accept and love me just as I was. I didn't have to put up a front. I was just me and he loved me for that very reason. His kindness gave me permission to remember the trauma I had suppressed, to grieve over the people I had lost, and to actively rebuild my life. Since we met, Dave has supported me with astounding generosity. He has donated thousands of dollars to the Look for the Good Project, as well as personally helped me restructure the nonprofit.

In the middle of all this, Dave's friends, Drew Hess and Maki Torres Fernandez, decided to volunteer their media skills to help me make this book. They paid for all their expenses while they collectively visited twelve countries to interview people about gratitude in both Spanish and English. I was particularly impressed by Drew's commitment since he had just been offered an opportunity to compete for a spot on the *The Bachelorette*, a dream come true for most guys! Instead, he decided to backpack through South America and Europe, sleeping in hostels, so he could

Drew Hess holding a Look for the GOOD card atop Illimani Mountain, La Paz, Bolivia
CONNECT: rewstertale.com

6 *Together We Rise*

Maki Torres Fernandez

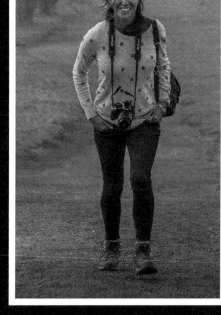

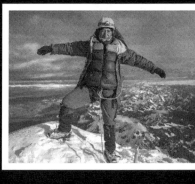

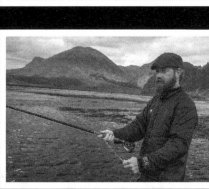

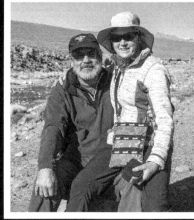

talk to strangers about their deepest thoughts. He even risked his life in Bolivia by climbing a 19,000 foot mountain to interview someone at the top!

Periodically, I would get email updates from Drew, accompanied with beautiful photo-interviews that rekindled my hope in the Look for the Good Project and my conviction to keep it going. In one of his emails, Drew wrote:

"The Look for the Good Project has given me many things. I started by thinking that I was merely a conduit for interviews in international locations. I'd been struggling with a lack of empathy for some time, and thought this could be a good way to break the ice with people, to hear their stories, and maybe somehow open up a little myself. Having never seen Anne conduct an interview (and knowing that she was on the opposite end of the emotional spectrum from myself), I hoped that my days conducting interviews as a sports editor in college wouldn't be too dry. It wasn't until my friend Maki and I were in a lodge in the Ecuadorian Amazon that I realized how much this project had affected me.

"We were sitting at the dinner table among a diverse group of international travelers talking about what we were grateful for, when they asked Maki and I what a typical response to the question had been. At this moment, Maki and I synthesized all the interviews into a couple points. Just a few hours later, we would conduct one of the most memorable interviews, where the people of an Amazonian village would explain how grateful they were that kids these days (thanks to motors on their canoes) didn't have to spend five hours a day paddling a canoe to and from school. I realized how many diverse stories we'd heard and how they affected my understanding of the people we'd come into contact with, as well as my experience on this trip. I was no longer just another backpacker – I had a purpose and was helping to tell other people's stories."

By taking the time to reflect on the people and experiences that enhance our lives, we begin to see that we are never truly alone and that together we have the ability to rise out of anything. I am thankful for Dave's friendship, Drew's commitment, and Maki's kindness which helped me regain my footing in the middle of a lot of loss and transition. Since then, I've moved to a safer place, restructured the nonprofit, revitalized my health and finances, and created this book as a fundraiser. This means that YOU can make a difference just by purchasing this book. 100% of the proceeds support the Look for the Good Hero Award, an annual scholarship focused on recognizing kids who have overcome obstacles to become inspiring leaders in their communities.

Our first award was given to a little girl named Gabby Matteis who shared her

story with me just after her father had
committed suicide. She had been in
the house when her father died and,
thanks to the guidance of her school
social worker, was able to channel her
grief into something positive. Not only
were we able to support her financially,
but we gave her an opportunity to speak in
front of 6,500 kids at the XL Center, three
hundred student leaders at the Connecticut
Association of Schools, and on television
through NBC CT.

As you flip through this book, keep in mind
that this is a compilation of essays and
photo-interviews collected by myself and
volunteers like Drew and Maki. I have
personally handpicked the stories you will
read, as well as designed every page. Not
only is this book inspirational but it
empowers kids like Gabby to be the best
they can be. In order for kids like her to
feel safe enough to look for the good, we
adults must set a good example. That's
why I am excited to share this book. I truly
believe that if you can't see the good, you
must *be* the good. Together we rise!

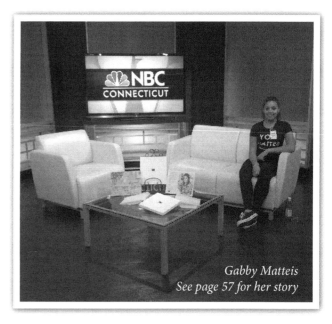

Gabby Matteis
See page 57 for her story

*Special thanks to Kelly Chapman and Lauren Robinson for their editing help, Justin, Merrillyn,
and Ray of Garcia & Milas Law Firm, Matt & Irene Kubitsky, Chris Zane, Cheever Tyler, Gus
Herlth, Diana Lyn Cote, The Lutian & Hayes Families, Cheryl Reed Pelosi & the Wonderful Staff
at Ocean Pointe, Ron Voller, Larry Koffler, Bill Curran, Renee McIntyre, Renee Moskowitz, and
W by Worth Clothing Line for your support during my period of transition and transformation!*

GOOD

NOTE: The landscape photos on the
following pages are courtesy of Drew Hess.

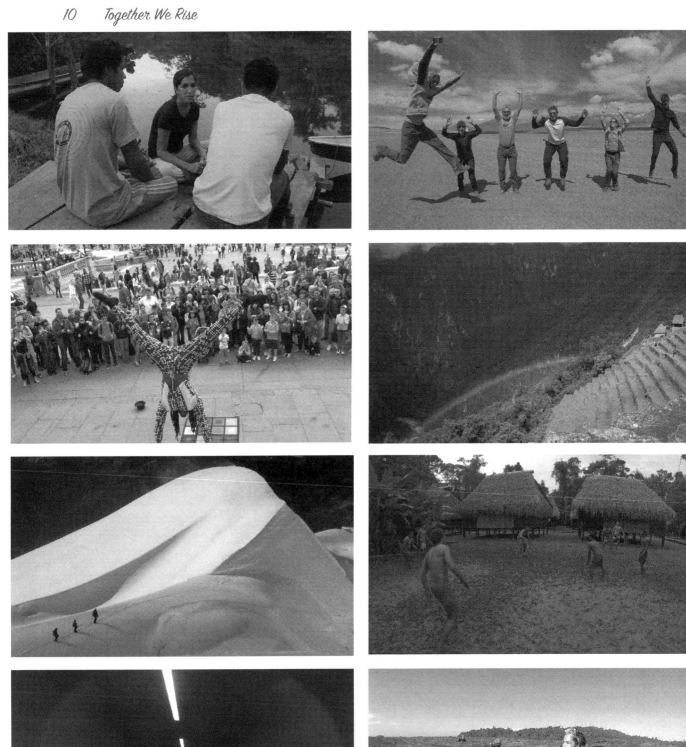

When you look for the good, you become the good, and inspire people wherever you go.

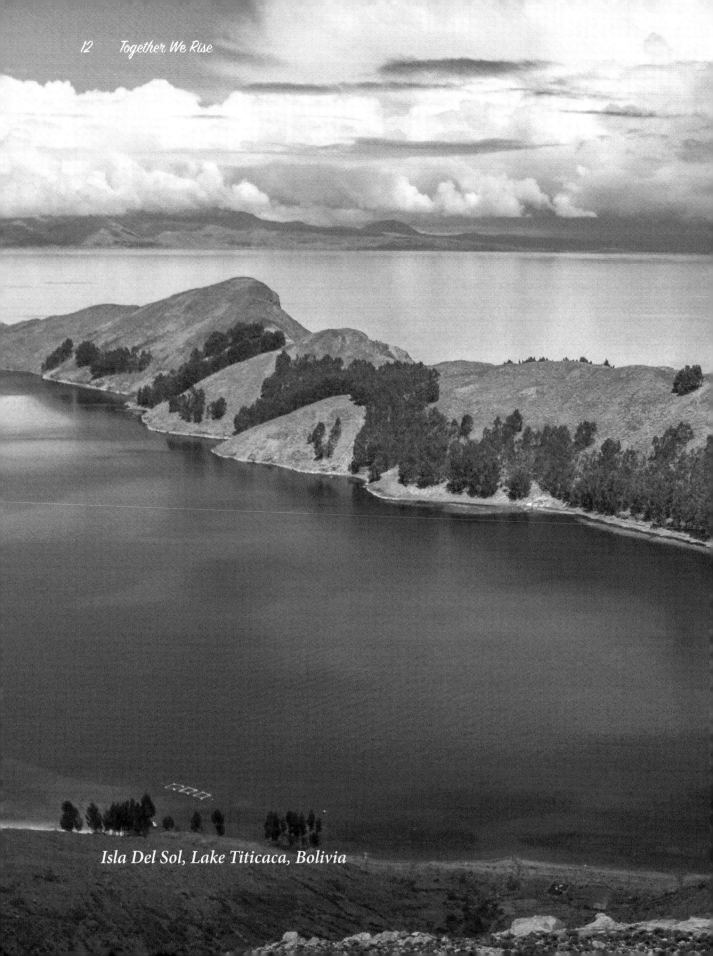

Isla Del Sol, Lake Titicaca, Bolivia

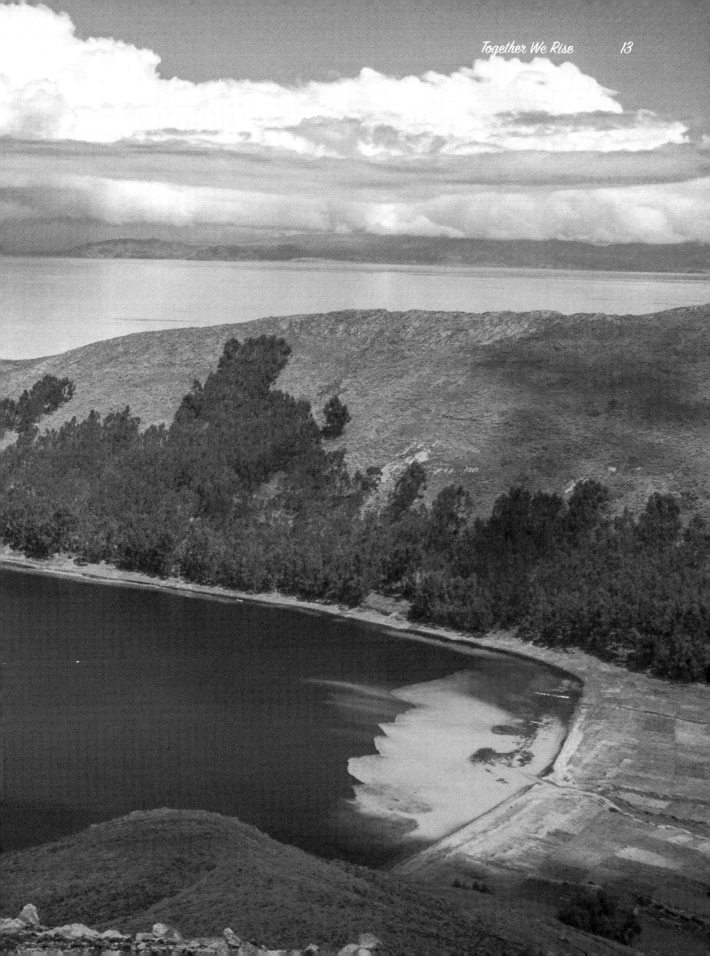

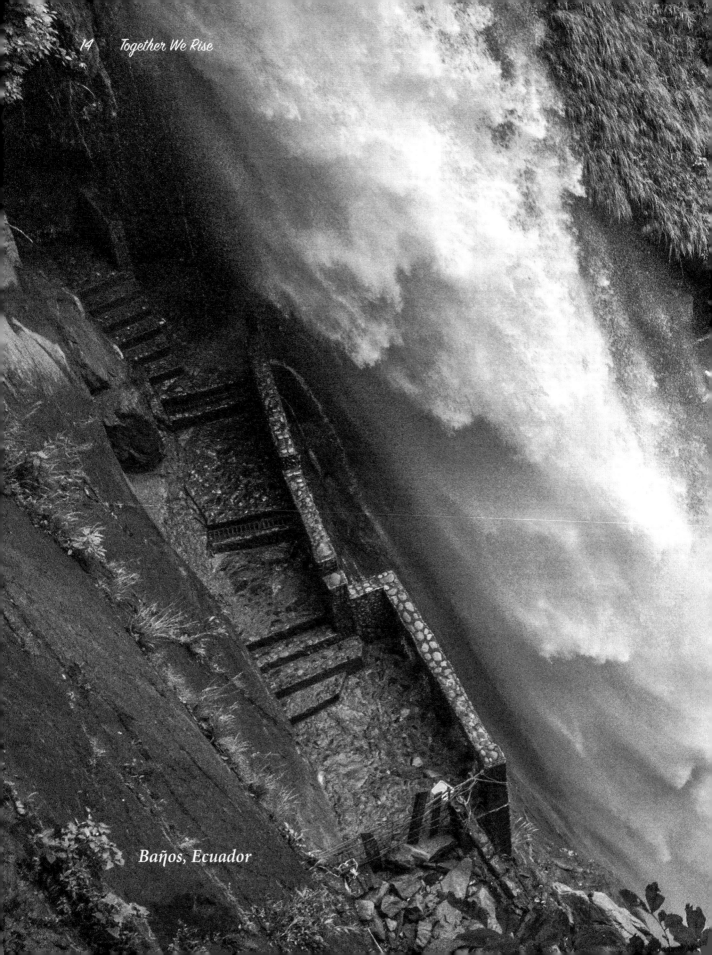

Baños, Ecuador

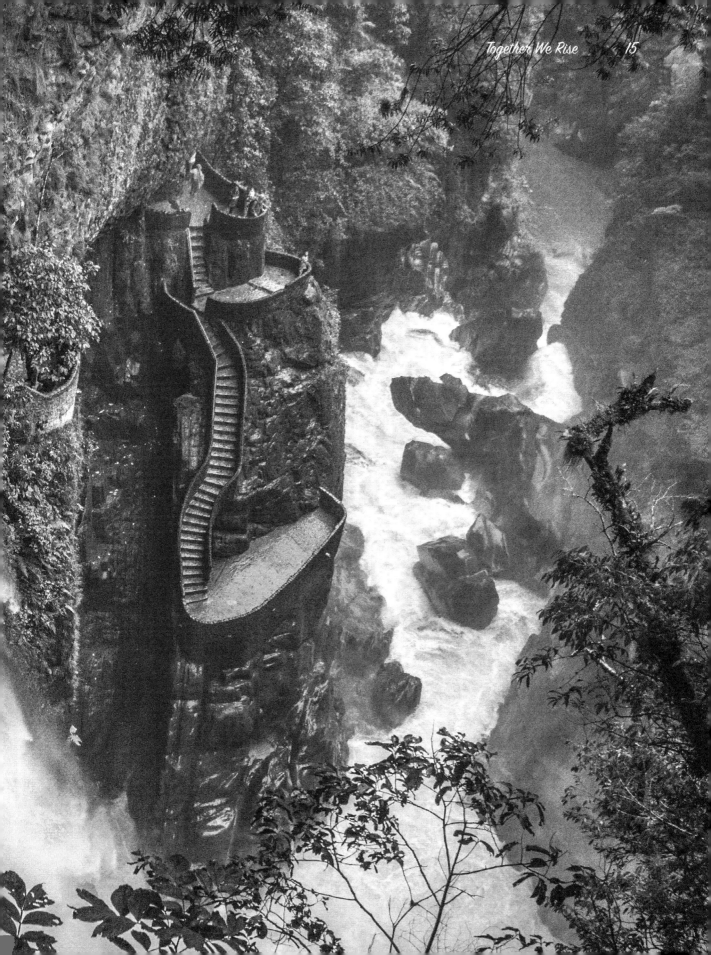

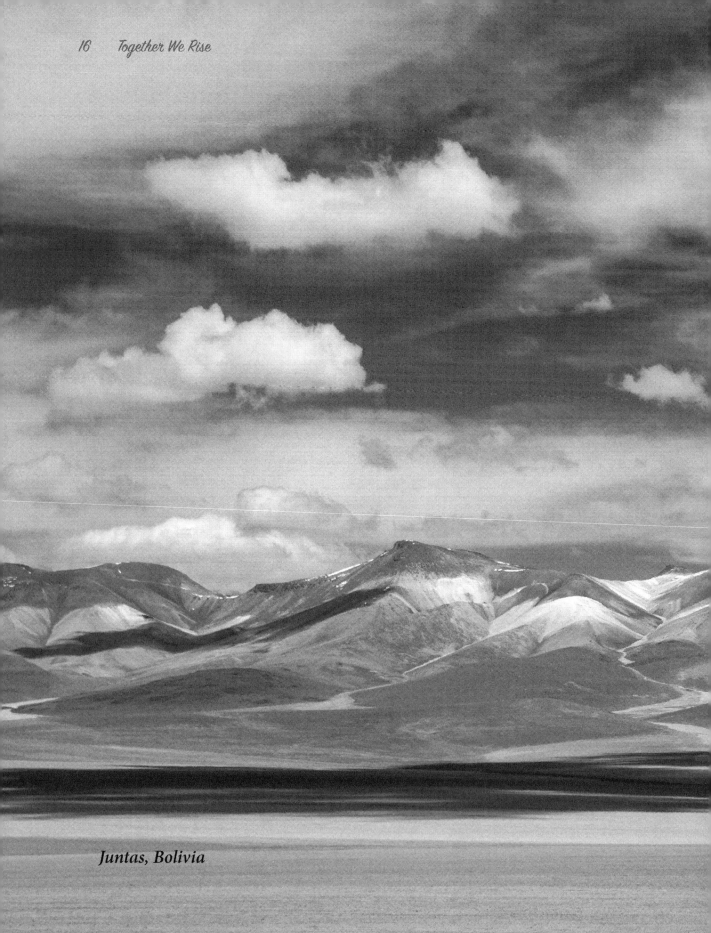

Juntas, Bolivia

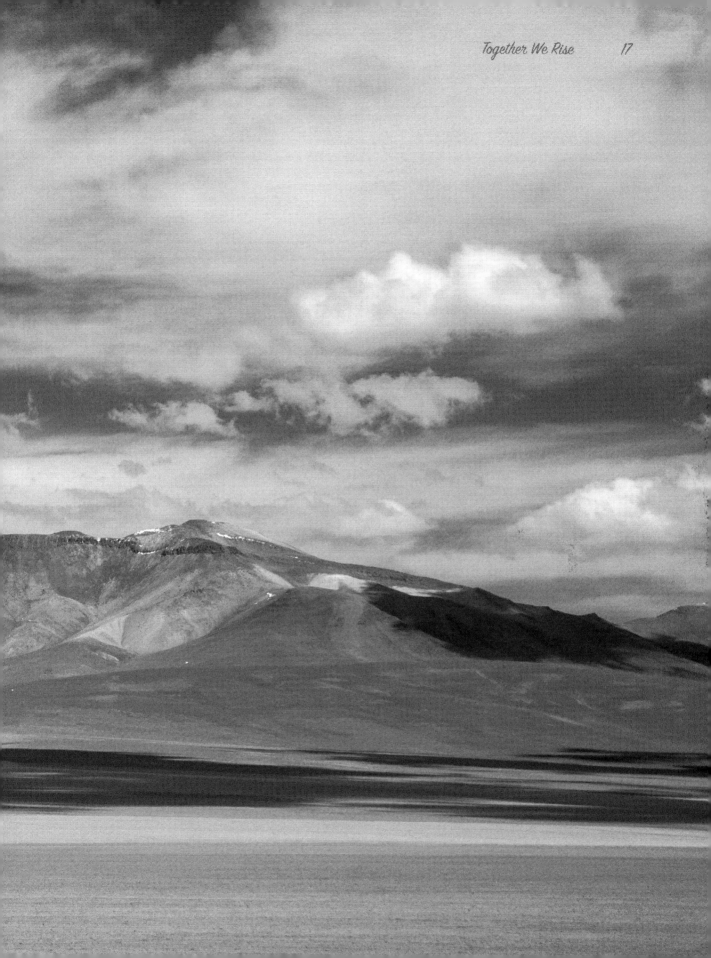

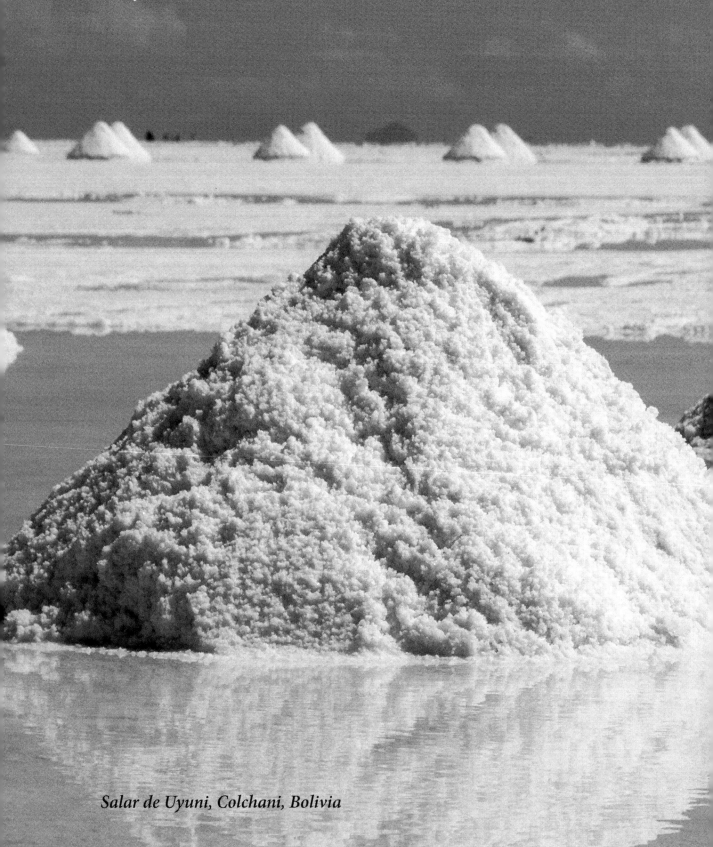

Salar de Uyuni, Colchani, Bolivia

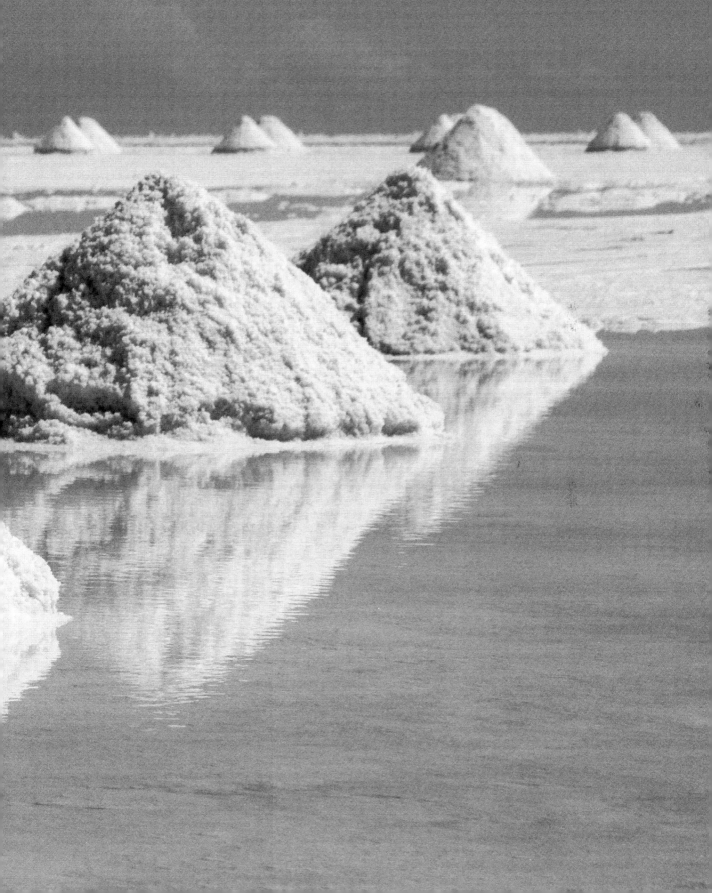

TARYN LONGO, FOUNDER OF WILD HEART FAMILY, WRITES:

There are many stories of gratitude I could tell. I could tell of my divorce at a young age, and how I left an entire world, an entire life, when I left my husband. I could tell of why I needed to leave my husband at 27, because of the cheating and the drugs and the daily fear that I lived in. I could tell of the events that led to my sobriety, of the trauma that I faced within myself to get there. I could tell of those first sober months for me, when I felt I had almost no one, and the way gratitude saved me in my loneliest moments. I could tell so many stories because I have lived so many lives.

Instead, I want to talk about the empty spaces we have inside our hearts, the ones that ache every day, at seemingly random times. The aches, one could argue, that led me to all of these stories.

Before I knew what to do with these empty spaces, they led me to some of my darkest moments. Those empty spaces would fill with self doubt, with anxiety, with fear, and would impact how I chose to live and who I chose to surround myself with. Those empty spaces created a life that was destructive.

I feel that most of us know those empty spaces in our hearts. Sometimes, when all is quiet, we feel them the most. Maybe nothing is really so bad, yet we feel like we are missing something. It's a sense of being incomplete, of not being enough or having enough, or being afraid of what it is that we do not have.

It took me a long time to learn about this. I mostly escaped these empty spaces – this sense of a void – through drugs, partying, dangerous partnerships with men, or simply running away from that feeling that something was missing. Escaping was the best choice for a while, because it seemed to be the easiest choice and the most available choice. And the more I escaped, the farther away I went, and the easier it became to keep escaping.

But when choices are destructive, you eventually meet your destruction. You will eventually have to face what you've been creating for yourself, and you will eventually be on your knees begging for help from powers you probably ignored until then.

I won't say that the way gratitude saved me was so linear. It wasn't so much that I was down in desperation and I had an epiphany that suddenly made me grateful

for my life. But I will say that in my lowest and most desperate moment, some little light of awareness peeked through and told me I deserved better. It's funny how one tiny shred of light can so effectively illuminate the dark.

For me, it was my first real tangible experience of grace, a power higher than me, because I remember that moment and to this day I can't understand any other way that light got itself through. But I felt the universe shift in one small moment, and I woke up to my worth, just enough to make a change. Just enough to find a piece of courage. From that point on, gratitude became an important filler for me.

One aspect of my change was that I was newly sober, and would sometimes find myself in moments of not knowing who I was or what I was meant to do. Gratitude would pull me back. Gratitude would give me something to center on that was good. I can still remember in those hazy first days of what had felt like a new life blossoming, a specific moment where I was grateful for water — simply water, with one little slice of lemon in it. Isn't that silly? But all these years later I remember the bottle that the water had been in. I remember the feeling I had drinking it, how good it felt in my body, and how grateful I was to be in the moment

I was in. My world was falling down around me, but that little bottle of lemon water was so good, and I am so touched that six years later, I can still feel the gratitude of that moment.

When you are sober, there is nothing to numb you or fill in those empty spaces in your heart. You feel everything, for better or for worse, and I believe that is why sobriety is a tough thing for people... even if they are not traditional addicts. People who are "sober" are sober because of their addictions. But ask a person who is not an "addict" to give up their nightly glass of wine, and most likely it won't be something they can do easily. It's hard.

How else can we fill those feelings of loneliness? How else can we feel whole if we feel something missing in our hearts?

I believe very strongly that gratitude is the saving grace. If, in a moment of lostness, we can feel the sunlight on our skin and be grateful just to be alive... if we can watch our dog run and play and be grateful for the simplicity of his joy... if we can find anything — *anything* — to be grateful for... it is the gateway to a sense of belonging. One drop of gratitude can fill our hearts and make us feel whole. Because in my experience, we ARE whole.

It's just that for whatever reason, we have these empty spaces in our hearts and we try to fill them with things that don't belong in there. We look outside, and get angry as a result. But inside there is a pool of gratitude to drink from, and all we need is one droplet from that pool to serve us.

This is how gratitude saves us. The moment does not have to be extreme; You don't have to find yourself in a deep crises; You don't have to be crying on your knees in order to pull back into gratitude. To me, gratitude is found in those moments *in between*. The quiet moments when you are with yourself, just yourself, and you begin to feel those pangs in your heart.

As this happens, I pay attention to my feet on the ground, I become present to the moment, I feel the sun shining, or I close my eyes and listen to the birds. I listen to life happening and become grateful for the simplest of things: For the ground that my feet touches; For the thump in my heart; It's amazing all the things you can feel gratitude for. I can't tell you how many times I felt gratitude for a stranger because they smiled at me when I needed a smile. Sometimes that would change my whole day! The smallest of things can bring the most overwhelming amount of gratitude.

And when the gratitude comes, I allow myself to smile, no matter where I am – even if I look silly. I bask in the gratitude the way a turtle would bask in the sun. I let it overpower me. It helps. It really does.

Gratitude may not change your circumstances in that moment. It may not make the person hurting you stop what they are doing. It may not bring you the home you need, or the relationship you want, or the job security you seek. But it will change your perspective, and changing your perspective will change your experience. Your experience of your circumstance is what matters, far more than the circumstance itself.

Over time, the more drops of gratitude we pull into our hearts, the more those drops add up, until one day, we don't feel so empty. We start to act from a place of wholeness rather than emptiness. We make different decisions and begin to cultivate a different kind of life. After a while, we don't need to run from the emptiness because the pangs of emptiness become reminders of gratitude. Every grateful droplet becomes a gateway to a new way of caring for ourselves and our lives. They become the seedlings of change and of growth.

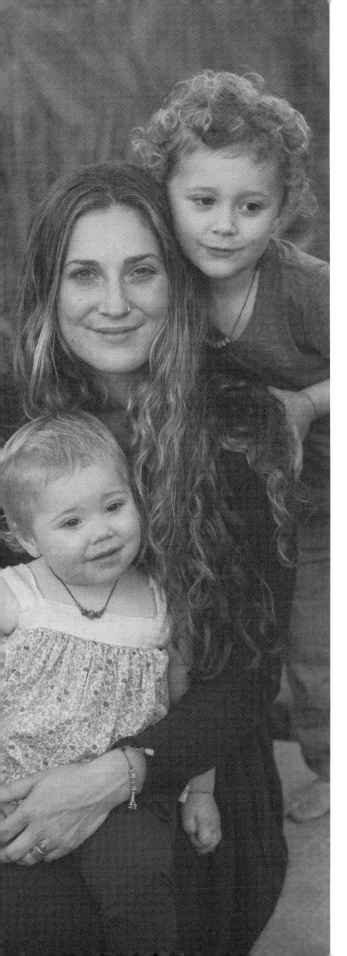

What is clear to me, all these years later, after I've built a new and beautiful life, is that the empty spaces we feel are small compared to the potential for change that we have in our hearts. Day in and day out, even now when I am living a life that is healthy and full, I take those in between moments to check into my heart and fill it with gratitude.

Right now, with me, close your eyes, feel the air on your skin, breathe it in, and let yourself feel grateful, for anything, even if it's just the air you're breathing. Keep breathing it in, soak it up, and then open your eyes and allow yourself to be in a new moment. Do this any time you need, as much as you need. Gratitude is always here for you, to fill those empty spaces.

CONNECT:
wildheartfam.com

Photo Courtesy of Taryn Longo

"I'm grateful that everything in life serves a purpose. You have to believe that life is taking you somewhere so that you can make a difference. Now I dance... I sing... I laugh... and I think of what I am grateful for every day. Life is beautiful no matter what. I'm grateful that I've learned to trust my intuition."

Photos & Interviews
by Corey Hudson

"A few years ago I was stroked by spirit — alive, clear and released into freedom. What appeared to be a 'stroke' to the panicked medical community was my 'awakening.' My paralysis was symbolic to the blockages in my life. My loss of voice and inability to communicate, as well as the loss of my right side (my giving and receiving side), allowed me to free myself from the idea of unworthiness and fear. I am forever grateful."

"On 9/11, I saw a lot of the ugly. The cars were on fire. There was smoke. People were in a very agitated and scared state, including myself. I felt like I didn't know what was going on. It was surreal. The next morning, people were coming back with pictures of their loved ones hoping to find them. Two hundred people were standing on this tile looking at these big pieces of metal and rubble and I kept wondering, 'How could someone possibly survive the devastation?' It was such a sad situation — especially for the people who were still looking. From that I realized I needed to appreciate life. Each day that I have is precious. So many people want to wish Mondays away. But I want to appreciate Mondays because Monday is another day of life that I have. Young people think that their lives are infinite. As you age, you realize that this isn't true. Appreciate the little things in life like a child does. It takes so little to make a child happy. As we get older, it takes so much. As I was leaving my previous job as a police officer, a young person in their twenties said, 'I wish I could trade with you so I could get a pension and not have to work.' I said, 'Would you give up twenty prime years of your life just to get a pension?' Many young people would say yes, not realizing the value of those years. After living those twenty years, I wouldn't trade them for nothing. The most important thing is life, family, and the people you encounter."

Photo & Interview by Anne Kubitsky

"I'm thankful for having the chance to move here which is a quiet place (I used to live ▶

in Buenos Aires). This school is better than my old school. We had one kid there

who jumped from the stairs because he was sad and tired of bullying.

Here it's different. Things like that don't happen here."

◀ *"I'm thankful for being*

alive and healthy."

Photos & Interviews
by Maki Torres Fernandez

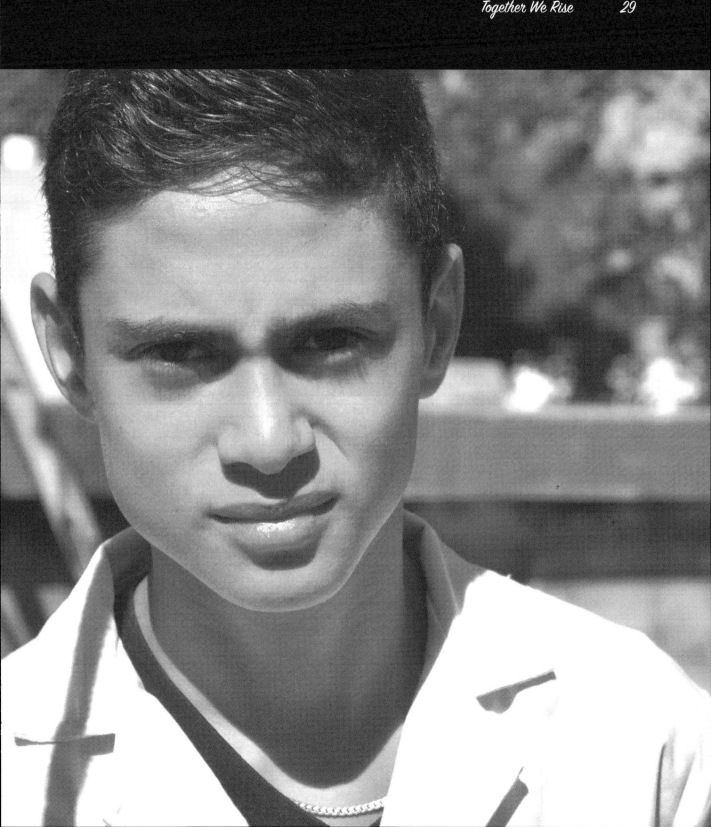

"As a farmer, I have learned so much from my parents. My dad taught me how to observe. He taught me how to watch the sky and pay attention to the animals. When people go to the supermarket, they have no idea where their food is coming from. For instance, I used to milk the cows in the morning and at night. We would collect the milk, filter it, and refrigerate it. My mom would then take the cream off the top and we would make ice cream. We put ash on the squash instead of chemical sprays; We use marigold plants to keep the worms away; And we make sure that nothing hurts the environment... as eventually everything goes back to the drinking water. I was brought up to try to keep things more natural and organic.

"I'm grateful for the farm, my family, my health, and the ability to learn. As a mechanic and a machinist (I'm an ASE master automotive technician for my day job), I can fix things and even make parts if I have to. I also seem to catch mechanical issues before they become major problems which is important because we can't really afford down time. I'm grateful for my abilities. If I didn't have these abilities I don't know what I'd do!"

Photo & Interview
by Anne Kubitsky

MT. ILLIMANI
BOLIVIA

"*I'm grateful for the mountains that call me to climb them. Mountains are what I really like. My goal has always been to climb. I'm grateful for the mountains because they teach me how to climb.*"

Photo & Interview
by Drew Hess

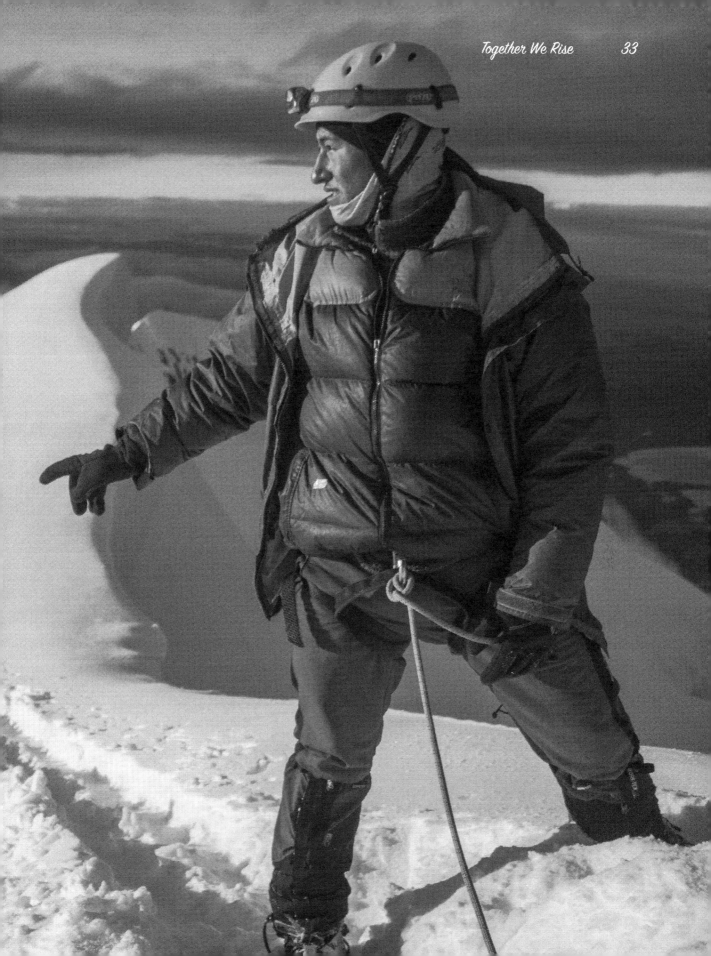

KERRI-LEE MAYLAND, NBC CT NEWS ANCHOR, WRITES:

You've heard it said before, "Television is just a bunch of bad news." Believe it or not, as a news anchor, I use newscasts to actually *look for the good*. I anchor both the 11 am and 5 pm newscasts, and some days are crazier than others. That's especially true for the 11 am where there's a little bit of everything sprinkled into what we refer to as the "Kitchen Sink" newscast. During the hour, we cover weather, sports, features, live interviews, and — at least twice a week — an actual kitchen sink during our cooking segments.

Once the team gets to the last block, we are finally able to exhale. Meteorologist Ryan Hanrahan and I banter on air around this time, and on one particular day, we talked about some of the less than savory headlines. That's when I suddenly blurted out, "This is why I watch *Ellen*!" Ryan laughed, and explained to our viewers that I was talking about the *Ellen DeGeneres Show*, our lead in for the 5 o'clock newscast. We were having a light moment, but Ryan knew I wasn't kidding because I've told him this before. In order to look for the good in my job, I watch *Ellen* while I'm in the makeup room getting ready for the show.

Throughout the day I catch portions of some of our other NBC network shows that also look for the good. *Kathie Lee and Hoda, Steve Harvey* — they've each made their shows about positivity and lifting others up. Working in television and covering things like ISIS... it takes its toll, especially when we view the videos that viewers (thankfully) don't get to see. Ellen reminds me on a daily basis that there is hope; There is love; There is Good. You just have to look for it.

My career has spanned a couple of decades now and I've had the fortune of working in some of the biggest news markets in the country. I was in Washington, D.C. during the Impeachment of President Clinton and the Kenneth Star investigation into whether or not the President had "sexual relations with that woman, Ms. Lewinsky." I traveled with the New England FEMA Task Force to Ground Zero within hours of the planes crashing into the World Trade Center towers. Gaining access to stories is the goal, but in this case, I saw things I could never have prepared for: Seasoned rescuers, the best of the best, breaking down in mental anguish and emotional exhaustion. Not long after 9/11, I got an anchor job in Philadelphia as Mike Jerrick's co-anchor on *Good Day Philadelphia*. I eventually went

on to work on every newscast at the station, launching several of them, and getting a taste of every day slot, while covering stories of both triumph and tragedy and doing what Walter Cronkite himself told me to do: Always be prepared, and go "beyond the headlines." It was during my time in Philadelphia that I did exactly that when I decided to learn more about the killing of a young Pennsylvania man named Nick Berg.

Nothing could have prepared me for what was done to this young man from Pennsylvania, slain mercilessly at the hands of Abu Musab al-Zarqawi in response to the Abu Ghraib torture and prisoner abuse. Nick Berg, a freelance radio-tower repairman, who went to Iraq after the US invasion, had nothing to do with anything that happened at Abu Ghraib. But he paid the price in a profoundly unthinkable way. While I was watching Nick's final moments, which tragically ended up being long and painfully drawn out, I kept thinking that I should turn away. But wasn't it my JOB to watch so that I knew what I was reporting on? I was pregnant with my first baby (a son), watching something I couldn't imagine his mother ever recovering from: Her son Nick Berg was savagely beheaded. The heinous details are unnecessary, but I was forever changed that summer day

at the computer. Not only am I not the same person because of what I saw, but I wondered if looking for the good in my career (and actually finding it!) was possible amidst all of the bad.

I still think of Nick Berg. In fact, I think of each and every person I report on and yes, there are times I want to weep. The animals, the babies, the kids, the innocent victims of bullying, the elderly scammed, the murdered and molested — the list, tragically and almost hopelessly, goes on and on. But I have learned that no matter how horrific the headline, I can indeed look for the good and find it. It's in the vigils, the good Samaritans, the children that fundraise for sick classmates and change the world around them because they learned that they can. It's the way communities come together in times of crisis and rally to get their members back on their feet. It's in the surprises, laughter, and plain simple fun on some of the shows on my own network. And sometimes it falls right into my lap.

As I was finishing up this piece for Anne Kubitsky (who I first met when she was a guest on my 11 am newscast), an NBC CT photographer came over to tell me about the video she had shot that day for my evening newscast report. It was about

a group called "Leaps of Faith." They give freedom to those left physically challenged by disease or accident by finding ways to help them fly down mountains on skis that have been adapted to their needs. My photographer was excited telling me about her experience, and the fantastic video she was able to get. I told her I would write as quickly as I could so she could edit the piece before she left for the day. We both glanced at the clock, which showed that she didn't have much time before the end of her shift. Reading my mind she said, "Don't worry about it, I'll stay late. Aren't stories like this why we do what we do?" I kind of choked up, but she didn't notice. Instead I smiled and said, "I'll get to work."

Sometimes you find the good even when you're not looking for it, even in the darkest of places. Ellen DeGeneres ends her show by saying, "Be kind to one another." I'm going to end this by saying, "Go ahead, I dare you to look for the good too!"

*"I have learned
that no matter how
horrific the headline,
I can indeed look for
the good & find it."*
- Kerri-Lee Mayland

Photo courtesy of Cody
Ripa of NBC CT

"I'm grateful I have a job where I can help people find their power... their light, their purpose, and that I get paid to do that. I'm finding myself much more grateful for people who give both positive and negative charges because I learn so much about myself. It's like looking in a mirror. It helps me have more compassion for myself at the end of the day because you can't see anything that isn't inside yourself. I'm also grateful for being able to sit with the uncomfortable things without trying to prevent them from coming. I'm really very grateful for my awareness.

"I'm [also] grateful I had a break down when I did... it stripped away all the bullshit... left me with what mattered... and helped me start over again with my heart. I'm grateful for this whole feeling as I talk about all of this... I get that feeling that I'm right where I am supposed to be. I'm grateful that I actually love myself because that took some work.

"Gratitude has helped me open. It's helped me stay in the flow and I think it's helped me inspire others to find their own gratitude. I have a meditation I do with people where I have them breathe gratitude into every bone and muscle in their bodies. Gratitude has helped me find truth and... allows me to keep moving forward and to not get stuck in patterns"

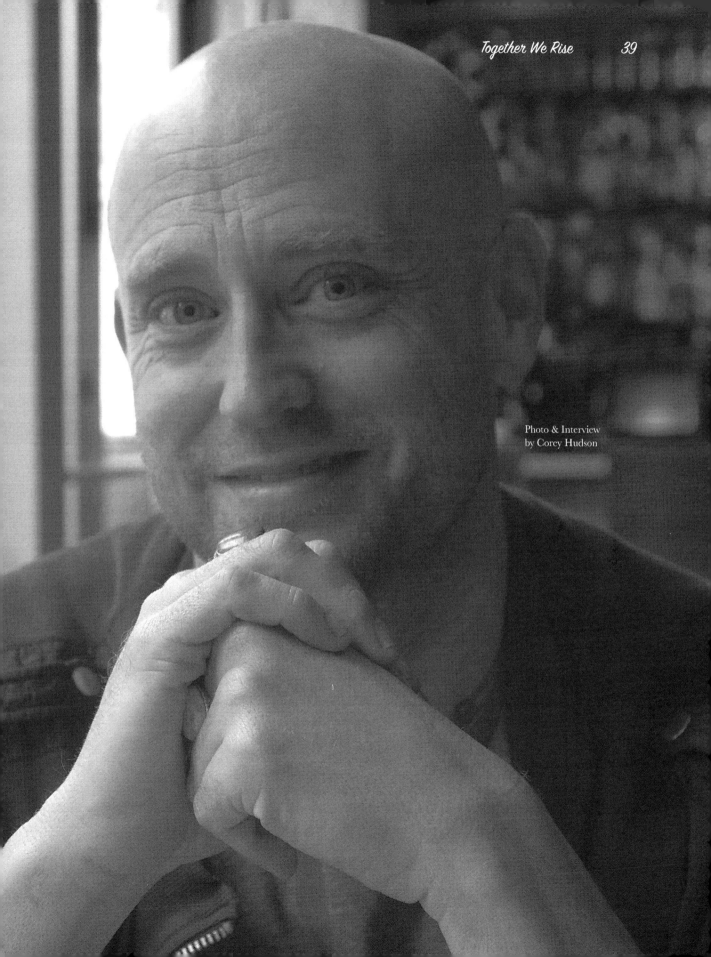

Photo & Interview
by Corey Hudson

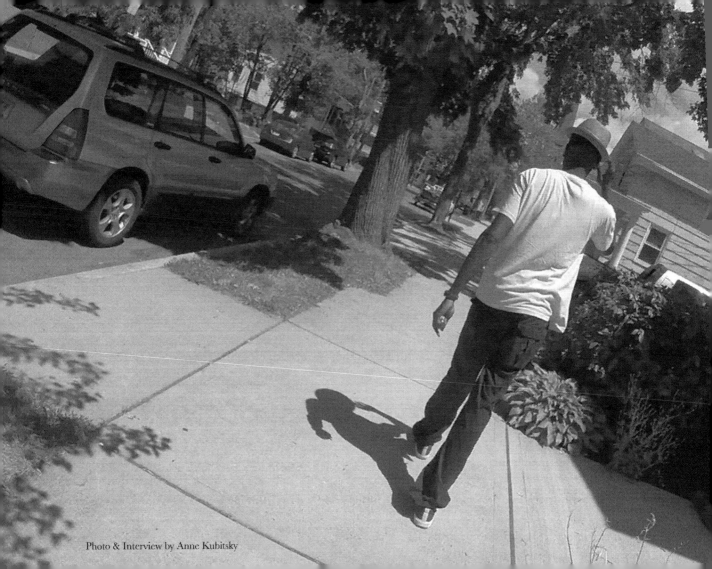

Photo & Interview by Anne Kubitsky

"One day I was in my bedroom, down and out that day playing around with knives. I even had a gun in the house, but decided to tie an extension cord around my neck at a moment where I knew a person would walk in and find me... Of course the person came in and found me, I received the attention that I guess I was crying for, and I went straight to the hospital. They put me into a room and locked everything up so that I couldn't touch anything. I had to stay there all night until a therapist came the next morning and asked me about two-hundred questions pretty quickly. At the end of the whole thing, he told me, 'You're not really depressed. You're almost depressed but you're not clinically you-need-medication depressed. So I'm not going to prescribe you anything.' At that point I really started clinging back to God. It wasn't my first time doing it so I knew exactly how to get to it and how to do it again, and sure enough He started clinging back to me — visually, aesthetically, tangibly. Every time I would do something good, good things would happen. Every time I would do something not so good, there would be some negative feedback from Him until I knew what I needed to do. From that day forward, it became clear that my happiness, my joy, and my gratitude were not determined by the amount of money in my checking account, the type of car I drove, the possessions I owned, or quite frankly, what other people thought about me."

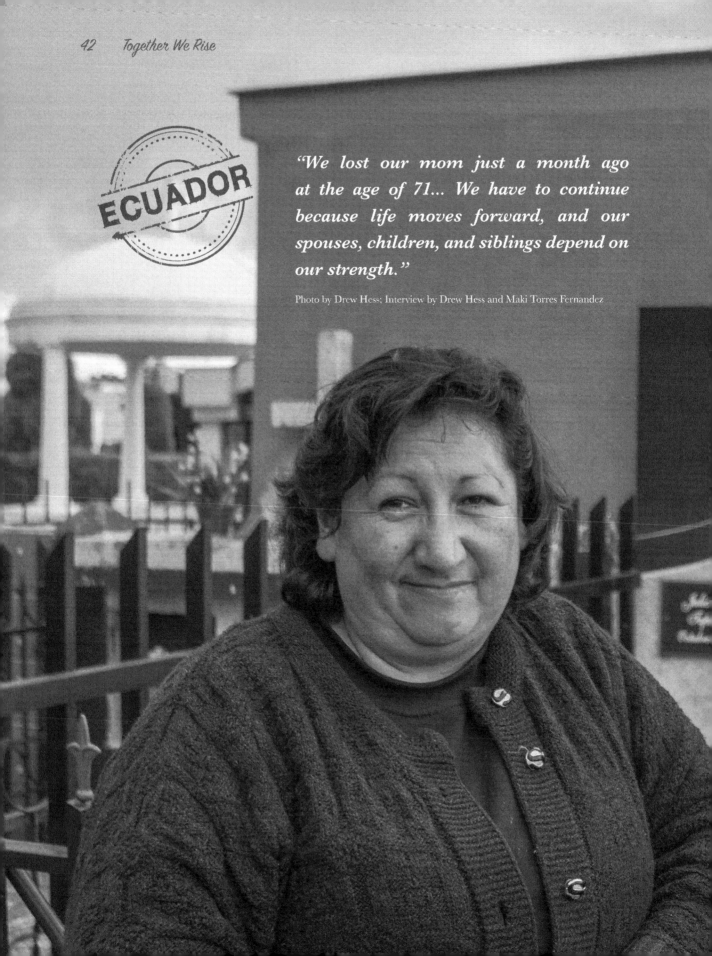

ECUADOR

"We lost our mom just a month ago at the age of 71... We have to continue because life moves forward, and our spouses, children, and siblings depend on our strength."

Photo by Drew Hess; Interview by Drew Hess and Maki Torres Fernandez

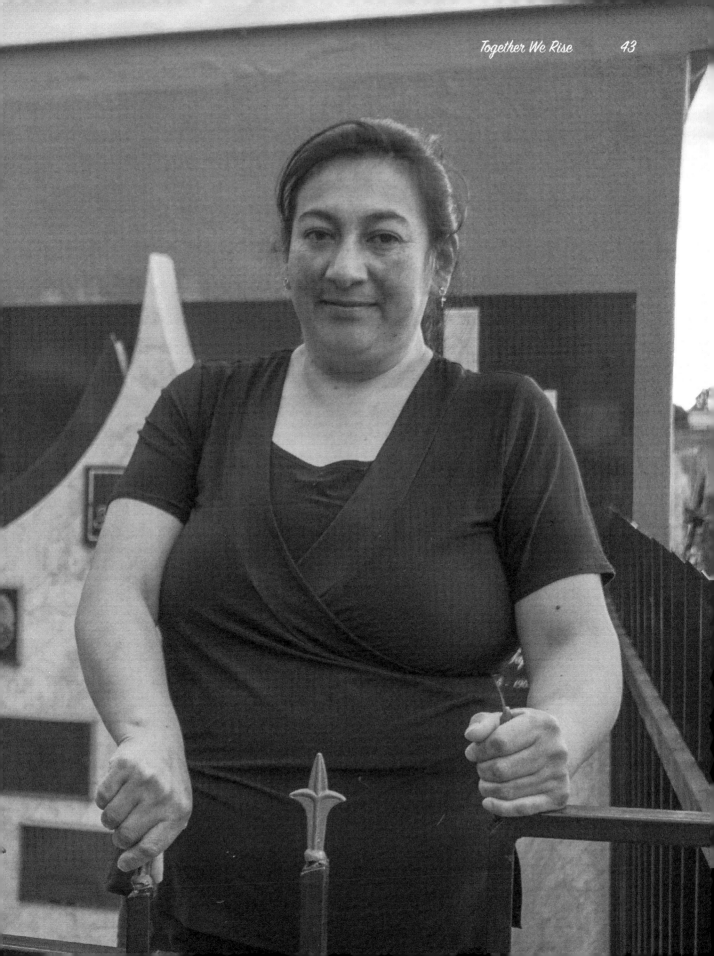

"I am hugely thankful for becoming a doctor — it's a very privileged position to be in. I love the cross section of the general public that I meet, and I feel that I have experiences from other people's lives that I would never get from any other situation. I am also very thankful for my faith. It has helped me in many situations and it's very special to me. I traveled with a charity to Lourdes in France, which is a Catholic pilgrimage place. We cared for people with disabilities, and that's when I thought, 'I really want to be a doctor.' I wasn't exactly a straight A's kind of student, so I had to work incredibly hard and was very lucky to get a place in medical school. I am eternally thankful for that. In medicine you see strength in such adversity. It's that kind of extra element to human beings that is, for me, what God is."

◄ *"I'm grateful that my boyfriend has been very supportive of me going off around the world to do medical missions."*

Photos & Interviews by Drew Hess

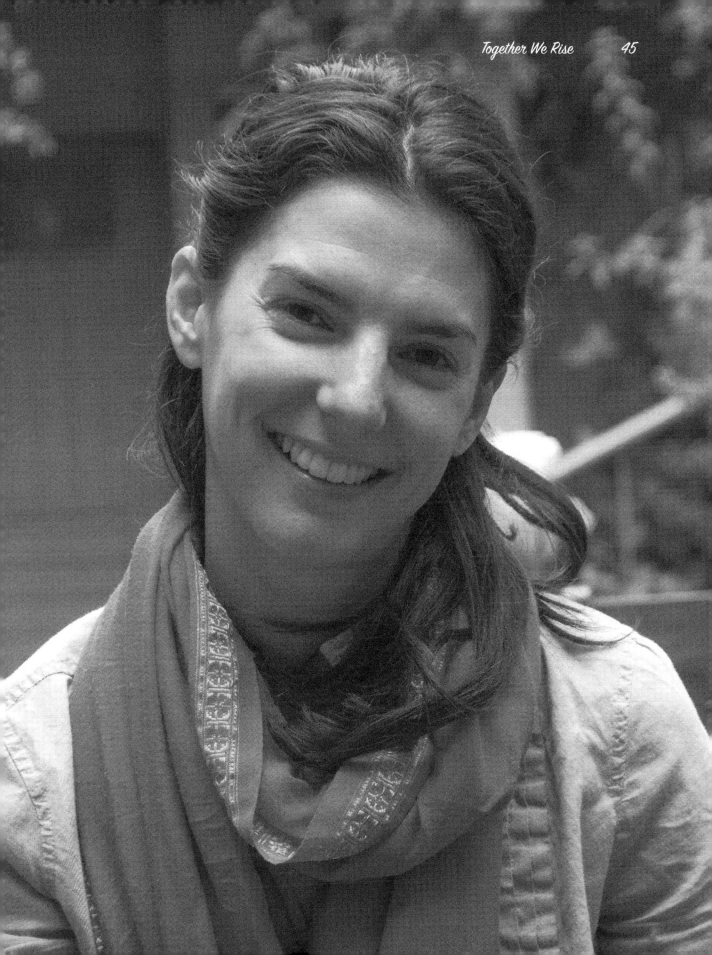

ALICE DUTTON WRITES:

One afternoon near the end of my father's life, we sat together on the edge of his bed in the nursing home. He was a wraith of a man by then, as gaunt and bony and weak as a concentration camp survivor, but no man or woman had done this to him. Pancreatic cancer had gone into remission for almost two years, allowing us to hike together on Sundays and hear him tell me about his life, about his regrets, even about his marriage. He wanted so desperately to tell me about himself, perhaps sensing that his time was limited, but he didn't give me room to tell him about me or about my son of whom I was so incredibly proud. And now, true to his fears, the cancer was back, and it was angry and hungry, and was consuming him oh so quickly.

Daddy was crying and I gently rubbed his back, stumbling over each sharp bone in his spine. I had never seen him cry before and found that I was unable to speak. "I'm scared," he whispered and then, almost too softly to hear, "I love you." This was the first time in my life that I remembered him saying those words to me. It had always been easy for him and for my mother to say "You know we love you," but I guess impossible to say those

three little words. As I sat there hearing "I love you," I could only hang on to myself and whisper them back. "I love you, too." I had never said them before either and they felt too painful to repeat, now that I was losing him.

We held hands, not talking, unable to say any more, surrounded by the heavy silence of a lifetime of the unsaid. I wanted to leave, to grieve for all those silent years, to hear those words again in my head, over and over. I wanted to stay, to greedily cling to the disappearing hours of his life.

The nurse brought my mother into the room, the mother who hadn't recognized me for years and just knew my father as Joe, a warm body who made her feel safe enough to fall asleep. Seeing them together was too much to bear and I hurried outside, needing to breathe.

The next morning, the home called to tell me that during the night, my father had tried to climb over the bed railings and had slipped between them and the mattress, and had begun to strangle. The nurse explained that they had revived him, but warned me that he probably only had a few days left to live.

He spent those days in a morphine-

induced haze to soothe and calm him, while I sat by his bed and held his hand for a few hours each day. I didn't know how to speak to him and my mouth refused to work. I assured myself that he wouldn't hear me anyway. All those things I longed to say were right behind my teeth, whirling in my mind, but somehow I was frozen.

Dad, do you really know who I am, what makes me happy, who your grandson is, how smart and caring and compassionate he is? Have I ever told you how much alike I think you and I are? That we have the same sense of humor? Do you know how very smart you are, even though you left school in the ninth grade? How thankful I am to have learned so much from you about music and literature and art and photography, and just creativity? I was so unhappy at home with Mom and crazy Rae. Why did you leave me alone with them? Why did Mom never really talk to me? Did she talk to you?

So much I couldn't say. Words that couldn't force themselves between my clenched teeth. I sat there and held his hand in silence and waited for his life to be over.

He died one night a couple of hours after I'd left for the day. I came back to his room in the home and forced myself to open the door. My father lay in his bed, his cheeks prickly grey with a shadow of a beard, a blanket pulled to his chin and his mouth gaping open as though he were pleading to have a little more time. I began sobbing and gulping and wailing as though my life had ended, instead of his. They had only been words. What would they have cost me? Now it was too late.

I stumbled to my car, drove home, and wrenched open my front door. Oh please be home, please be home. My teenage son answered the phone at his father's house. "I love you, John. I love you so much, sweetheart."

I had never known how to say those words to him. Words that my father had finally said to me as he was dying, and now, incredibly, I heard them again as my son said them back to me. "I love you too, Mom." I could hear the surprise and relief in his voice and I simply sobbed, loving the sound of those words, at last. It's my second chance. Don't forget! Tell him over and over and over for a lifetime.

www.tonymemmel.com

"He was born without fingers other than a thumb (symbrachydactyly). Our ultrasounds hadn't revealed this, so we had no prior knowledge or preparation. Soon after his birth, we found the Lucky Fin Project, a nonprofit that exists to provide information, raise awareness, and celebrate individuals born with symbrachydactyly or other limb differences, named for Nemo's smaller fin in the film, 'Finding Nemo.' We also found a local support group for children with upper limb differences and their families. I didn't realize at the time how important these two groups would become in our lives. Through this community, we met Tony Memmel, an expert guitarist and singer-songwriter who was born missing his left forearm and hand. Watching him perform was a turning point in my life. His presence and his music helped me realize that my son has a bright future ahead of him, full of possibilities. For that, I am eternally grateful. We've progressed from feeling isolated, to knowing that there are many families out there who share our truth, some who live only ten minutes away. We've gained a large extended family of forever friends, and I am so grateful for their love and support everyday."

CONNECT: luckyfinproject.org

Photo & Interview by Elizabeth Vandermark Huffman

"I am thankful for life bringing me here to the Osa Peninsula when my daughter died. I had a daughter who died fourteen years ago. I came here to recuperate during my time of mourning, and to be close with nature. To be truthful, it is a bit contradictory that through a big loss, I had the chance to become close to something that is now the passion of my life. Every day I am thankful for my health, and to be close to my brothers and sisters. I also lost my mom when I was only fifteen, and it seemed that death was always around me when I was young. I was very afraid of dying. I have overcome these losses by reuniting with nature."

Photo & Interview by Drew Hess

COSTA RICA

"I am grateful for believing in soul mates and true love. If you are fortunate enough to find it, you realize that love is something beyond the two people it encompasses. It almost becomes its own entity. That's not to say that you don't work at the relationship, but the 'relationship' is a different being than the love, if that makes sense. I also believe that two people can love each other completely and be happy but not have found their soul mate or experience true love. I recently lost my soul mate — my 'true love' — and it is the belief that love is its own entity that makes the hardest and darkest days a little easier. I have learned that true love doesn't leave when the body does. It is still here. It is stronger than any human 'thing' we can apply to it. True love survives even death. As I have explained to our children, the human soul doesn't 'get a new shell' like a hermit crab once the shell is broken. It isn't visible to the human eye and can't be heard through the human ear, but it remains, because you feel that love in your heart, and that is how souls truly communicate. Yes, I'd do it all again, even knowing what would transpire, because he was worth every second."

Statement by Lori Gates; Photo of Lori's family by Elizabeth Vandermark Huffman

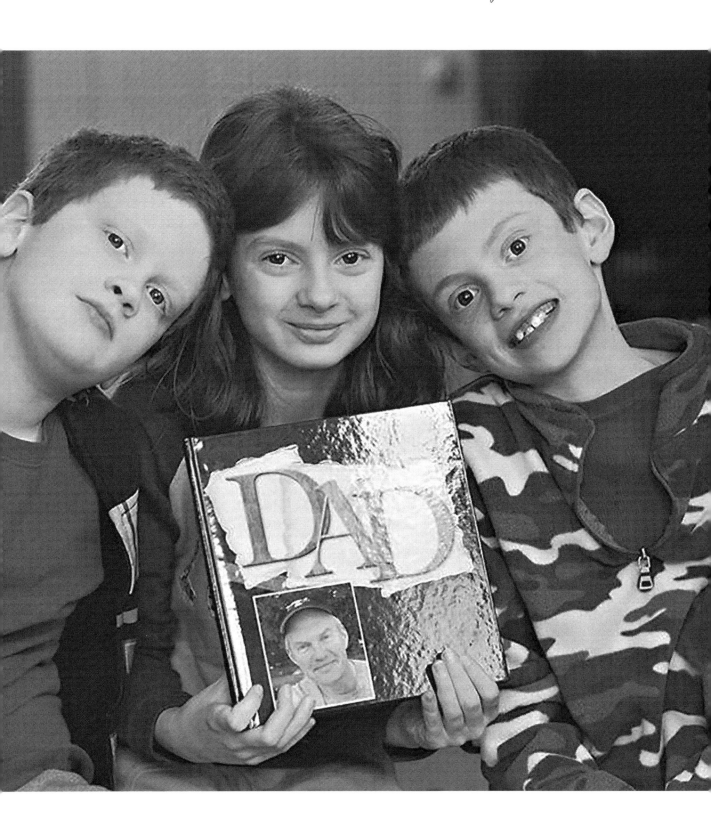

"In short, I think what I'm most grateful for is love. If GOOD is the lens that you look through life with, LOVE would be the frame that holds that lens. It's like you put your Love Glasses on with the Good Lenses, and life has a totally different perspective."

Photo & Interview by Drew Hess

COUNSELOR LYNN JOHNSON WRITES:

I have so much to be grateful for, including that I wasn't stricken by Multiple Sclerosis until I was thirty-eight years old. Blessedly, this allowed me to raise my daughter and travel in the world before I became physically impaired. To me, M.S. stands for "Multiple Stealing." It stole my ability to teach yoga, and to walk, run, and dance freely. However, it couldn't steal my soul. On the contrary: Struggling with this illness has brought me closer to God, deepened my compassion for others, and made me a better therapist. Still, MS relentlessly progresses, taking more and more abilities away.

I recently visited my sister Mary Keith. My great nieces and nephews came over to me and started dancing to her Wii, laughing and having a ball as their parents and my sister joined them. "Dance with us, Aunt Lynn!" they begged. I sadly shook my head, hating that I couldn't participate. The next day, Mary Keith said, "Come on Lynn, let's try!" She turned on the Wii and pulled out a chair, indicating that I should sit next to her. I listened to the beat of the music and watched the colorful figures move on the screen. I took the remote in my hand and followed the best I could with just my arms. "Look Lynn, you got two stars for your performance," she cheered. I laughed. I felt like I was dancing again!

For Christmas my sister gave me a Wii dance disc and I move every day to it now. Sometimes we may need a little help from our friends and family... but there is always good to be found. Helen Keller once said, "So much has been given to me I have not time to ponder over that which has been denied."

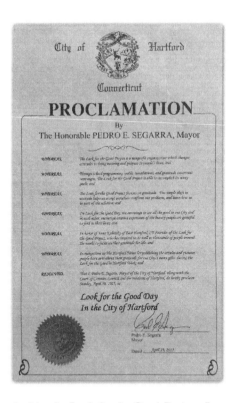

Inspired by the Look for the Good Project, Lynn Johnson asked her Mayor to declare a Look for the Good Day in the City of Hartford in April 2015!

TWELVE YEAR OLD GABBY MATTEIS SHARES:

At five o'clock in the morning, something went off in my head. I didn't know what it was until I came downstairs and I said, "Dad, are we allowed to get out of bed yet?" His girlfriend then came downstairs and said, "Go upstairs, you can't be down here right now." So she went upstairs and comforted us until the police arrived.

They blindfolded us as we left the house and took us away to the hospital. My mom told us that my dad passed away. I didn't believe it at first but when she started crying, I knew it was true. Then I started getting curious and looking into it more. When I walked into the kitchen, it had been dark and I couldn't see anything. But then I saw something on the counter and a body lying there with stuff all around it. At first, my mom wanted to keep things safe and just told us, "He drank too much and fell." But then when I was ready, I heard that he committed suicide from depression. This is why I'm raising money for suicide prevention. People believe that there's a cure and I don't want anyone else to have the same loss that I had.

The sad thing is that my Dad died and that he would do something like this. But now I know what to do when I grow up so that I don't have the same fate: I wouldn't drink; I wouldn't get too carried away and hold weapons in the house; And I'd also get a good job and stick with that job. What I'm learning is just because it feels like nothing's left, you still have a life ahead of you to meet new people. You just need to stay strong.

NOTE: Gabby was awarded the Look for the Good Hero Award in 2015.

"True story - When I was in second grade, growing up in Brazil, I ▶
remember telling my grandma, 'Wouldn't it be cool to have a job studying
sharks?' And here I am as an adult, in the same line of work, doing something
that I love. Yes, it's a surprise because I never thought that I'd be doing this. But
my last paycheck from an employer was October of 2001. It's always a lot of
work, and it's not always easy, but I really can't see myself doing anything else.
I am grateful for being part of a wonderful family, for having my health (which
I think is the most important thing), and also for being able to turn my dream
and my hobby into my business which is something positive that encourages
children to develop. I feel like I'm really contributing to society with
Batfish Books so I think it's a match made in heaven."

CONNECT:

batfishbooks.com

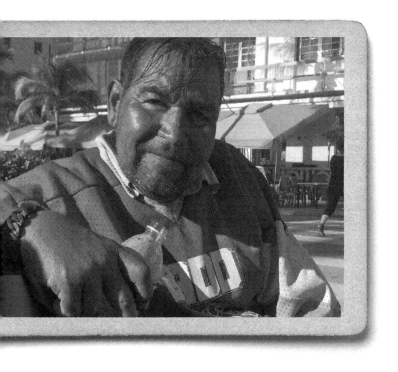

◀ *"I'm grateful for meeting you*
because you're making me smile
today. My first smile for the
whole day was from you. Your
smile made me smile."

Photo & Interview by Anne Kubitsky

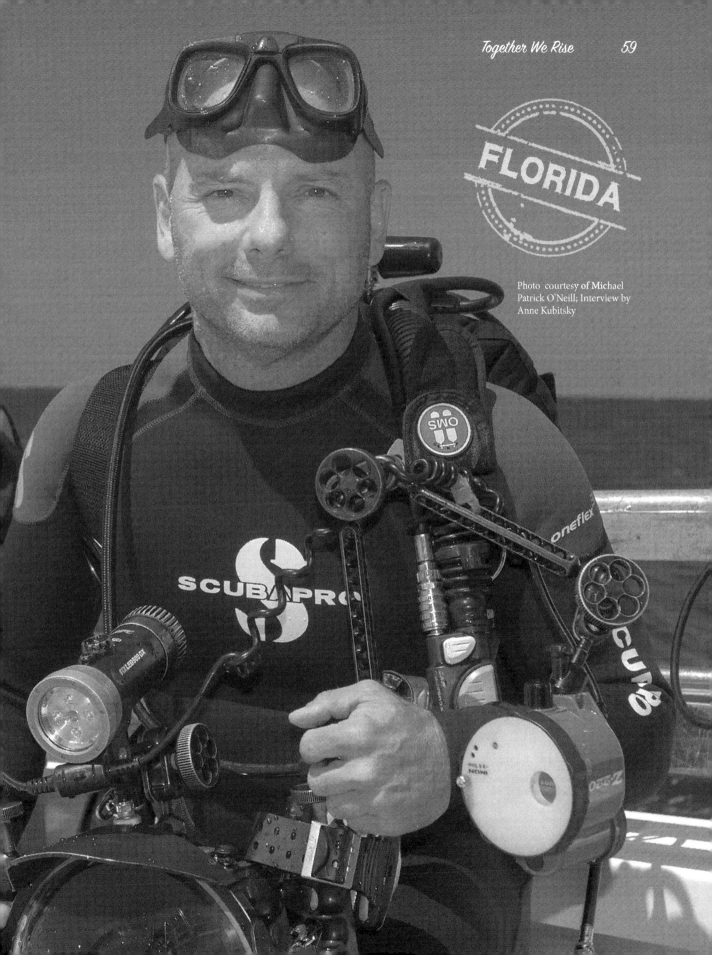

FLORIDA

Photo courtesy of Michael
Patrick O'Neill; Interview by
Anne Kubitsky

"I'm grateful for women."

Photo & Interview by Drew Hess

BOLIVIA

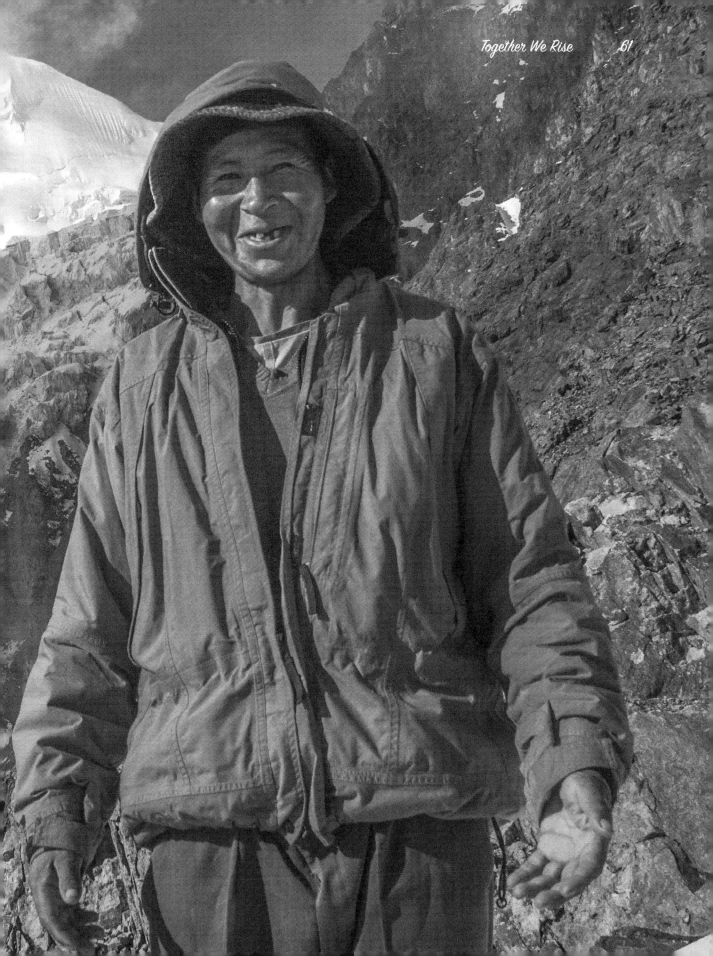

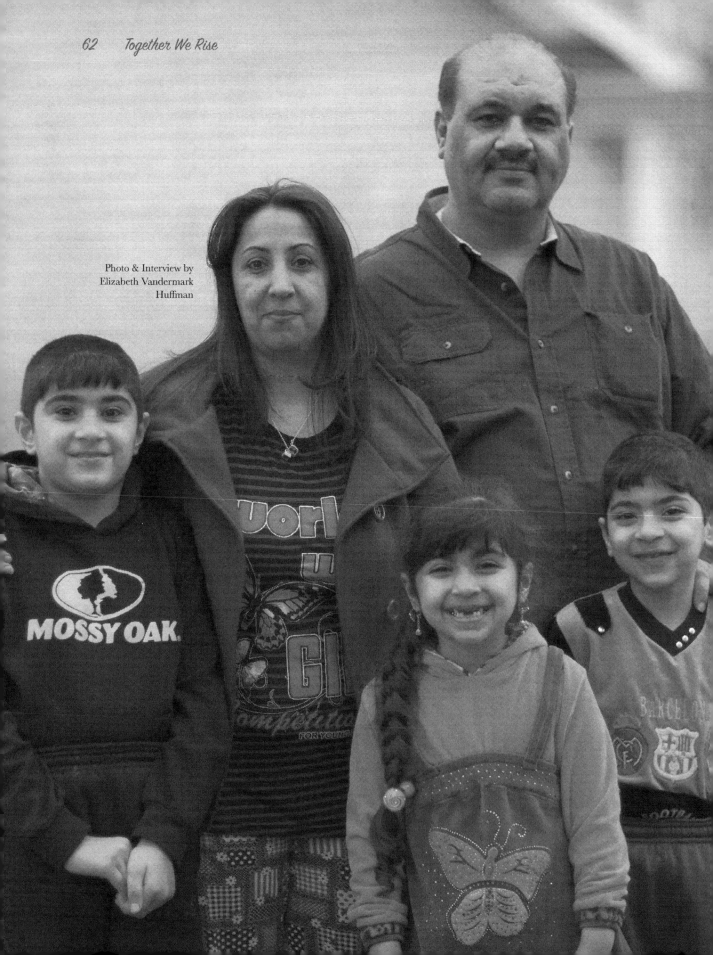

Photo & Interview by
Elizabeth Vandermark
Huffman

"I am from Iraq and I am an electrical engineer. My family and I lived in Baghdad. After the war happened, Iraq was an unsafe zone to live. Killing... kidnapping... all these things happen to people every day and we know many people who have been impacted. To be safe and keep my family safe, I moved to the US. We now are in America, my kids are safe and happy, and that makes me happy."

Photo & Interview by
Corey Hudson

"I like this project! It gives a lot of people self-esteem. Instead of focusing on the negative, it focuses on the positive."

GAY RIGHTS ACTIVIST
DAVE KNAPP

Photo by Elizabeth
Vandermark Huffman;
Interview by Anne
Kubitsky

"Realizing I was gay... getting divorced... being forced out of my church... and getting kicked out of the Boy Scouts because of my sexual orientation... those four things were the best things that ever happened to me. I think I'm a better person because of these traumatic and painful experiences. I'm glad I was forced out of my church because I am more fulfilled in my current church. If I wasn't kicked out of the Boy Scouts, I would still be working as a volunteer. I mean, how can you fight the policy if you're working as a volunteer and still in the closet? My efforts — along with the help of many others such as Scouts for Equality, my church, and my local Boy Scout Council — are affecting two and a half million Boy Scouts right now. That never would have happened if I hadn't been kicked out. These four terrible events make me grateful because if I was still in the closet, married, in my old church, and a Boy Scout, I would be leading a totally different life. I would not have accomplished all the things that now make a difference in other peoples lives. I really thought I would be dead before the Boy Scouts changed their policy on gay membership for boys seven to seventeen because, at eighty-eight, how many more years do I have left? I'm very grateful that I am alive to witness this policy change, after surviving an aggressive prostate cancer five years ago. I think God works in mysterious and wondrous ways. When bad things happen, which they do, sometimes God can take the bad things and bring good things out of them like He did for me."

CONNECT: stonewallspeakers.org

NANCY WORTHEN WRITES:

My daughter Margaret always fought for the underdog. If she saw that someone was struggling, she would help them. There was a young man who actually wrote to me after she died and he told me a story about when he was having seizures in their high school. If he had a seizure, everyone else would run. But Margaret would sit down next to him, on the floor, and she'd hold his hand and wait for someone to come and help him. She didn't even know him that well but she knew that he needed someone. That's the kind of person she was.

When Margaret had her stroke, she was in college. She was just about to graduate. It was May 10th. Her graduation was on the 21st. She was finishing up her last paper that morning and was probably a little tense and anxious to get home. She had a headache and wasn't feeling quite right. By the time her friends found her, Margaret was on the ground.

She ended up going to the hospital… and then another hospital… until they found that she had had a severe brainstem stroke. She wasn't able to move, eat, speak, and — for the first eighteen months — show any form of consciousness. Her doctors thought that Margaret was in a vegetative state, but I felt differently and pushed for another diagnosis. We participated in a research project in New York City. I took Margaret there about five times because they were interested in her case. The researchers saw that her brain was perfectly normal — just like another person her age. Her brain was active and her verbal and motor areas were totally lit up, which was kind of interesting because she wasn't talking or moving. As a result of that, she got speech therapy which was basically to practice moving her left eye (the only part of her body that she could control) so that she could say yes and no and perhaps make choices about her care.

As I continued to care for Margaret, I met this woman who was an art therapist who had a lovely way about her. So we met with Margaret and began doing art therapy. First, we worked with clay which was hard to manipulate. So then we tried painting, which was perfect because of the way Margaret's hands were. It was easy to place a paintbrush in her hand, then hold her hand, and move it with the brush. This method of art therapy is called "Hand over Hand." Over the years, we made some beautiful artwork together!

In addition to this therapy — or maybe as

a result of it — Margaret began to have very slight connections in her brainstem that enabled her to speak seven times over the nine year period she was locked in her body. One evening, for example, a nurse was getting her ready for bed and had just gotten her tucked in and changed. She gently asked Margaret if she was comfortable, never expecting Margaret to reply. But Margaret said, "Thank you," quite clearly! At that point, it had been six years after her stroke. Margaret couldn't move; She couldn't talk; She couldn't eat; But yet she said thank you to her caregiver because she was grateful for the care she was receiving. To me that's just who Margaret was. That's who she always was. She was kind.

Three years before her stroke, Margaret wrote this letter to me:

I just wanted to take a minute to say thanks for being a great mom. I'm so excited to come home and talk to you in person. I know that I haven't been exactly on top of your birthday and Mother's Day these past few years, but I just wanted to be sure you know that I really appreciate having such a wonderful mom and friend and I truly hope that someday I can fill your place in my life with my children (if that makes sense). Many things in my life so far wouldn't have happened without you being there through my ups and downs and in betweens. I hope that someday I'd be able to show you that I was worth the investment (time & money wise), wherever I end up. Love and Kisses, Maggie

I cherish this note. It reminds me not to wait to tell someone that I love them because you never know what tomorrow will bring. If you care about someone, tell them. Be specific. Say, "I love you because you're courageous." Or "I love you because you're strong." There were so many things I loved about Margaret and I am grateful that I told her before her stroke... after her stroke... and every day until she died.

NOTE: The Look for the Good Hero Award was originally set up in memory of Nancy Worthen's daughter, Margaret Worthen. Each recipient must embody Margaret's resilient spirit, who — even in a severely debilitated state — was able to express kindness to the people and animals around her. 100% of the proceeds from this book support this scholarship award. This photo of Nancy and Margaret was taken before Margaret's stroke.

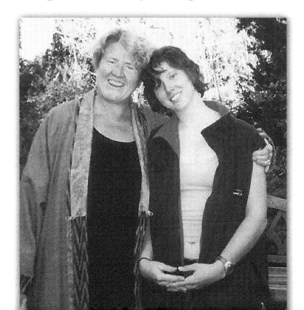

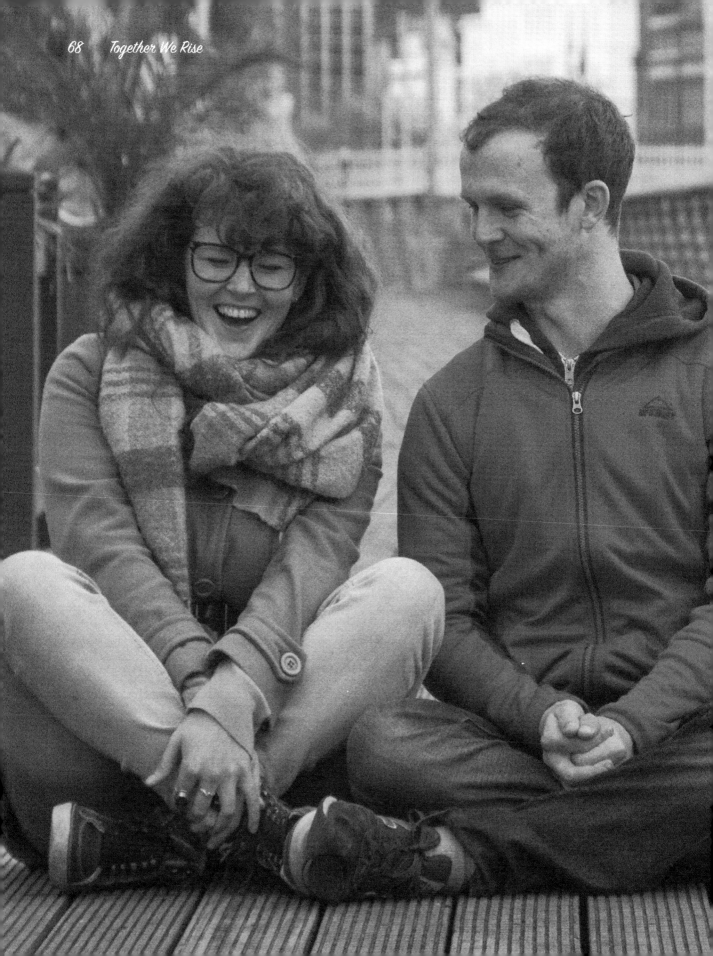

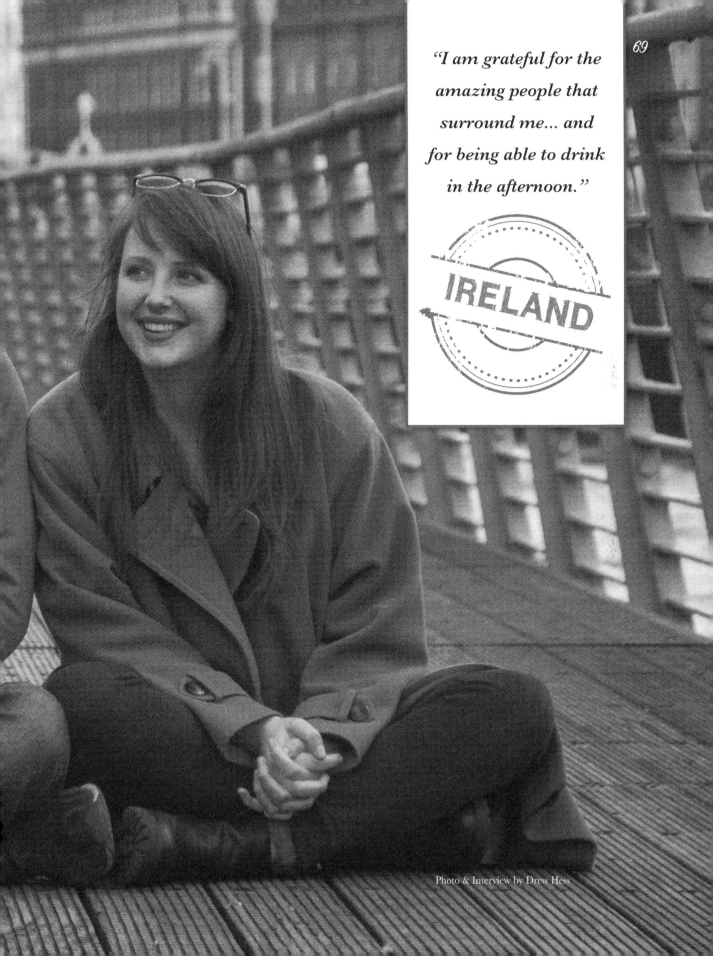

"I am grateful for the amazing people that surround me... and for being able to drink in the afternoon."

IRELAND

Photo & Interview by Drew Hess

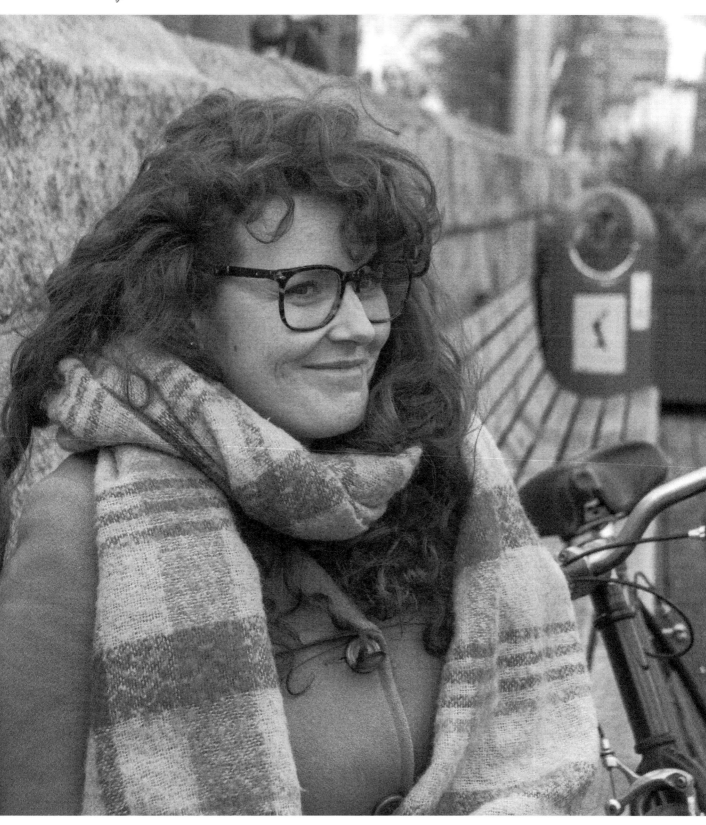

◀ *"I'm grateful for a bike accident that happened this time last year because it forced me to leave a city that I didn't actually know I wasn't very happy in, and come back to Dublin where I'm so much happier. At the time, especially in the weeks right after the accident, it was the worst thing that could've happened. But in hindsight now it's the best thing that could've happened."*

"I'm actually really grateful for where I am right now. I am very lucky that I'm here in Dublin in my mid-20s, with clothes on my back, some money coming in, an education, and prospects for what I want to do. Anything that does happen to me is ultimately up to me and nothing is stopping me. I have food in my belly; I'm thankful for my friends and my family; and that most everything is given to me. The reason that's important is that it keeps you humble, and keeps you doing worthwhile things." ▶

Photos & Interviews by Drew Hess

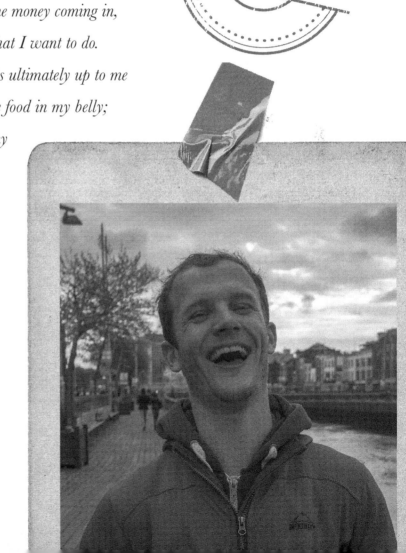

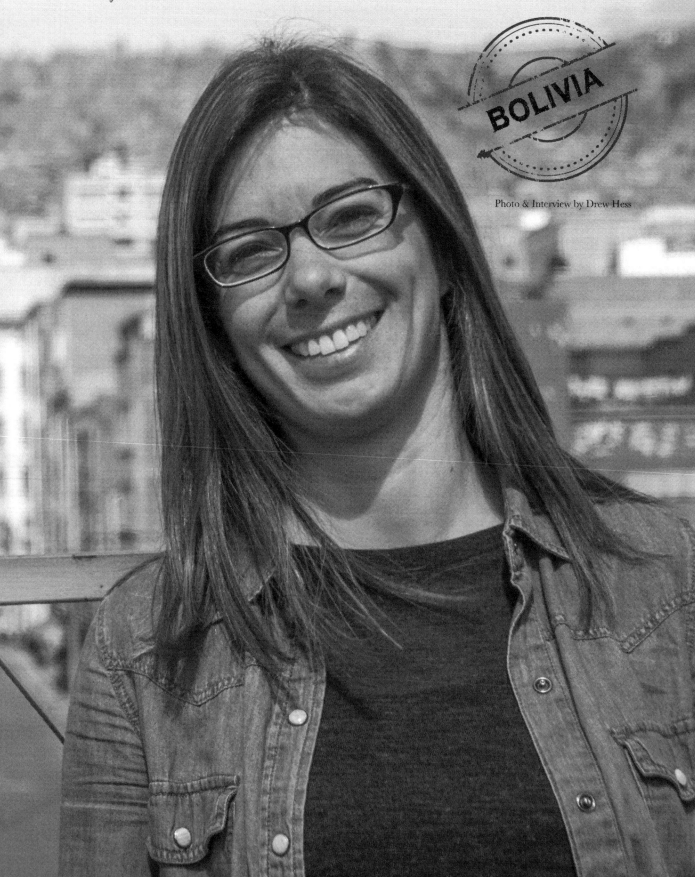

BOLIVIA

Photo & Interview by Drew Hess

◀ *"I am really thankful for being able to see. During my travels, I have seen such wonderful landscapes. My aunt has a very strange kind of glaucoma and she's losing her eyesight. Unless you have an experience like this, I don't think we really appreciate how wonderful it is to be able to see."*

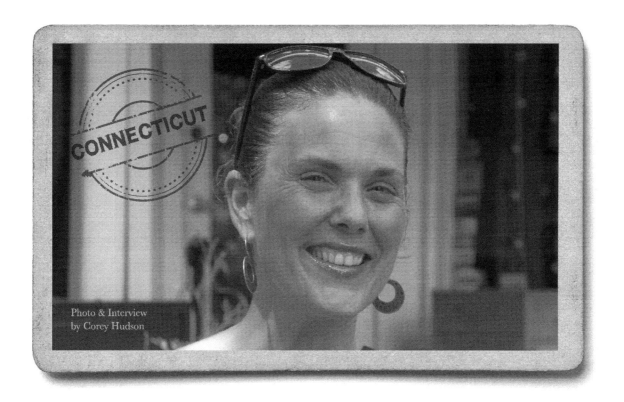

Photo & Interview
by Corey Hudson

▲

"It seems like people are more heart connected, truth seeking, and searching for their authentic selves now... It's creating this beautiful evolution and it's a great and exciting time to be alive. I also like how freely people are giving their gifts to the world right now — people feeling seen and heard. The focus is not about things anymore. It's more about the feelings in your heart."

"I am grateful that there are still places on Earth where there is almost no one — where you ▶ *can pull back from the hectic city life of electronics and technology. I'm grateful for the birds singing in the morning and evening, while you watch the sunrise or sunset. I'm also happy I have brothers and sisters so I can travel without feeling bad that my parents don't have anyone at home... and that they support me in my interest in traveling. Traveling has made me realize how friendly people can be in other parts of the world. People are always offering a seat or making room on the bus."*

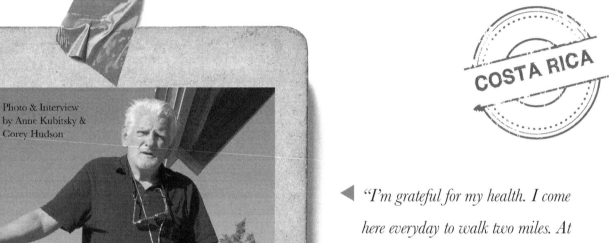

Photo & Interview
by Anne Kubitsky &
Corey Hudson

COSTA RICA

◀ *"I'm grateful for my health. I come here everyday to walk two miles. At sixty-eight years old that's quite an accomplishment for an amputee."*

CONNECTICUT

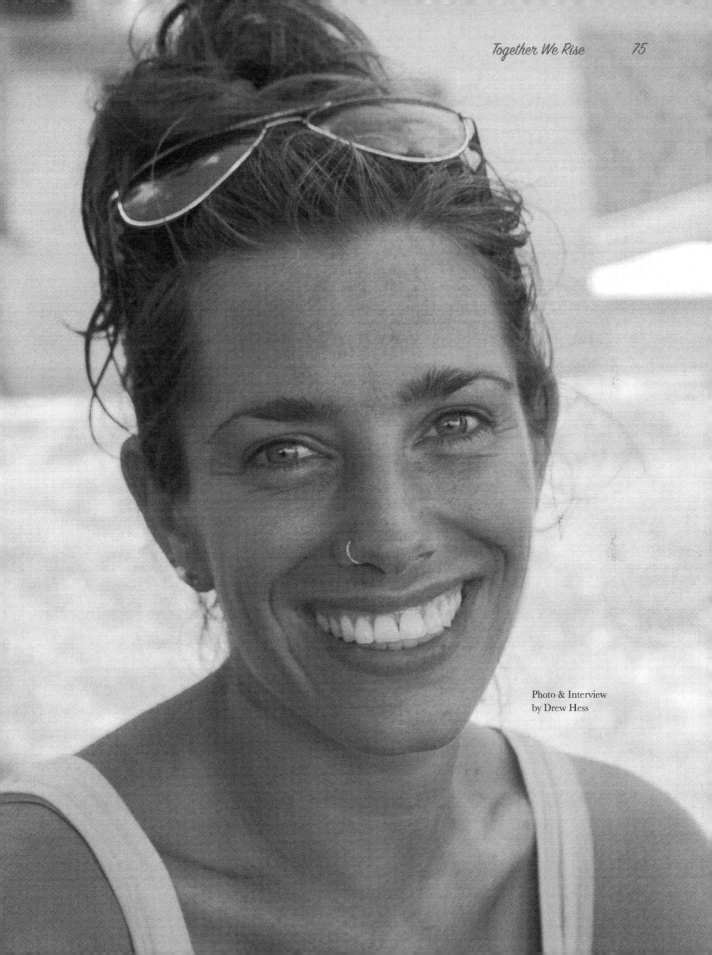

Photo & Interview
by Drew Hess

"I'm going through a divorce... I got laid off from my job... and I'm losing ▶
custody of my son... so those are the sad things I'm dealing with. I live
in a shelter right now but the thing I'm grateful for is my father in Puerto
Rico, who has been helping me start my life over again, and for all the love
and the support that he's given me. I heard a lot of things about mothers...
there's nothing like them... but fathers are very important too. So I thank God for my
dad. That's what I'm grateful for... and all the wonderful people in the world that
have helped me through this tough time in my life. That's what I'm grateful for."

▼ *"I was in a really bad car accident. I broke everything from my neck to my femur.*
I am just grateful to be able to walk around."

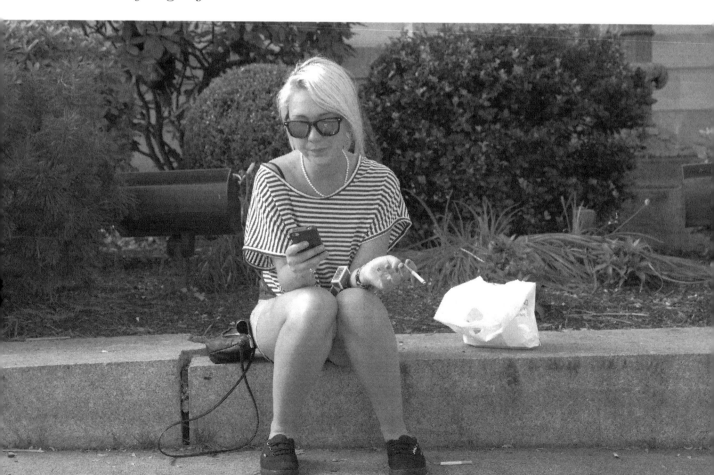

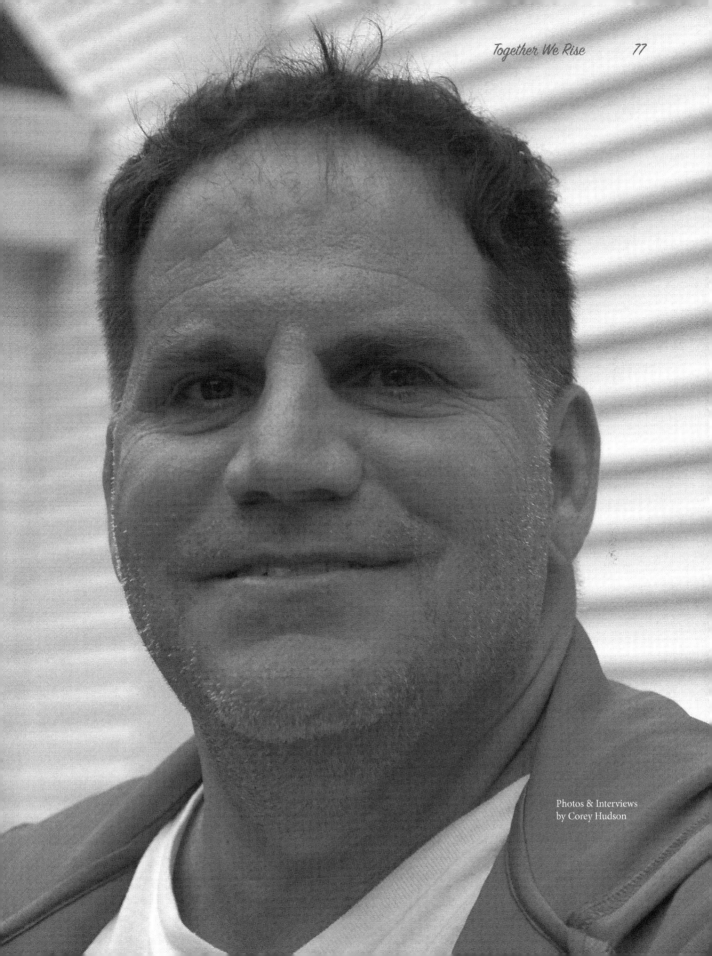

Photos & Interviews
by Corey Hudson

Photos & Interviews
by Corey Hudson

◀ *"I'm grateful that I'm alive. I just lost my home. A drunk driver crashed into my building and caused a fire. Even though I am in between, I'm grateful that my art and life survived, and for coming to a concert and hearing the music. Music is healing."*

"We are putting together a bag of stuff for the guy who lives under the bridge, so I'm grateful for where I am... where I live... food in my fridge... and a bed to sleep in." ▼

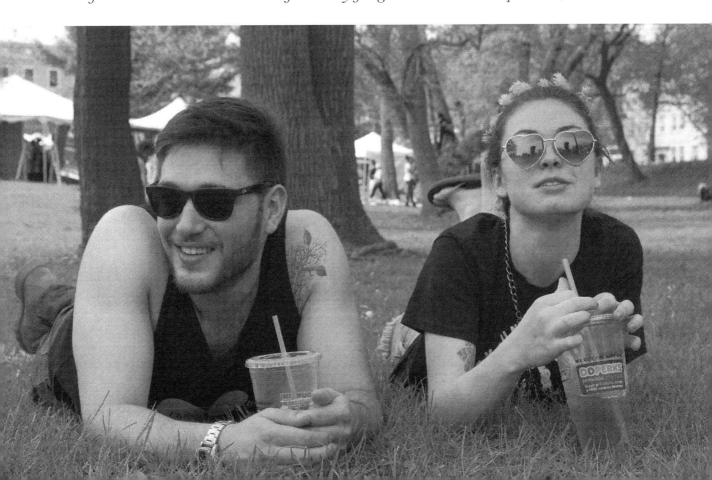

"I'm most grateful for my independence. I'm grateful to have the freedom and choice to do what I want, when I want. We live in a society where so many women are not able to do what they want to do and I am grateful I live in a place where we are free. People weren't surprised or shocked when I decided to quit my job and travel. It's nice to be able to have that freedom. A couple of years ago my parents separated. I couldn't really deal with it very well, so I left. I moved out and very quickly had to grow up and fend for myself. Now that I've dealt with that, I can see everything in a different light, I am more happy as a person, and I feel that my life has come full circle."

Photo & Interview by Drew Hess

"I work every day — from Monday to Sunday. The ingredients to make the ceviche that I ▶ sell come from far away. The driver already knows I need it, so he leaves it at my home. It takes a lot of investment. I've been making ceviche for seventeen years and everybody knows me. They call me 'La Macha.' I have a lot of clients who always come and ask: 'Macha, are you there?' If I am not, they come to my house. I'm grateful for my job every day."

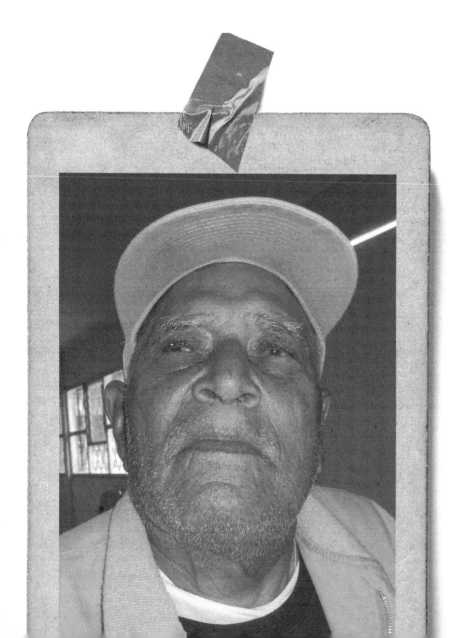

COSTA RICA

◀ "I lost my sight twenty-six years ago. For twenty-one of those years I am grateful that my housing has been free."

Photos & Interviews by Drew Hess and Maki Torres Fernandez

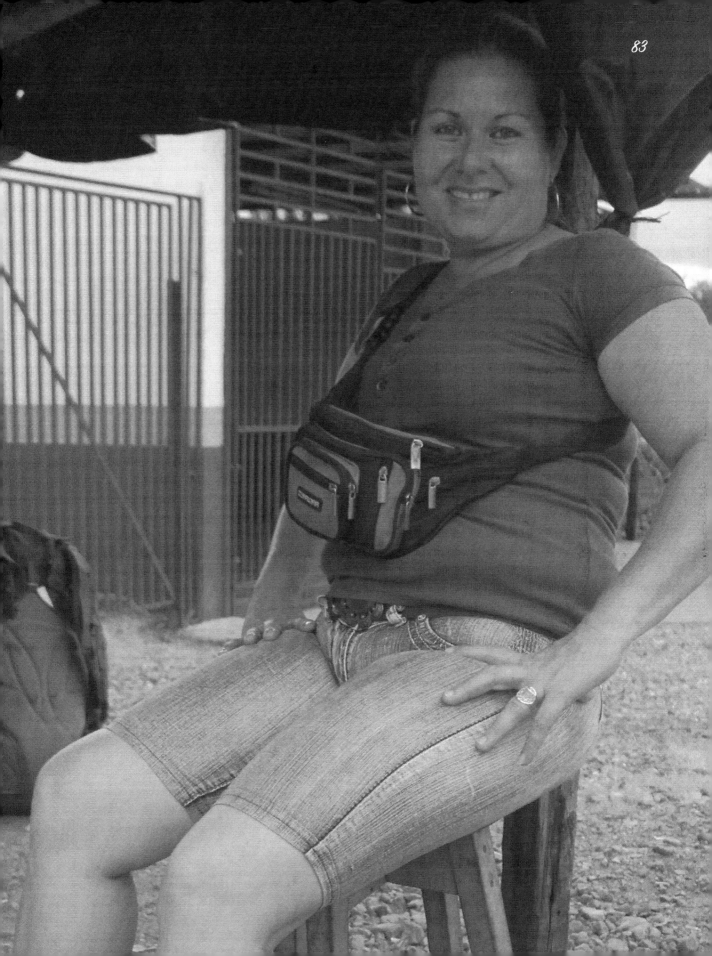

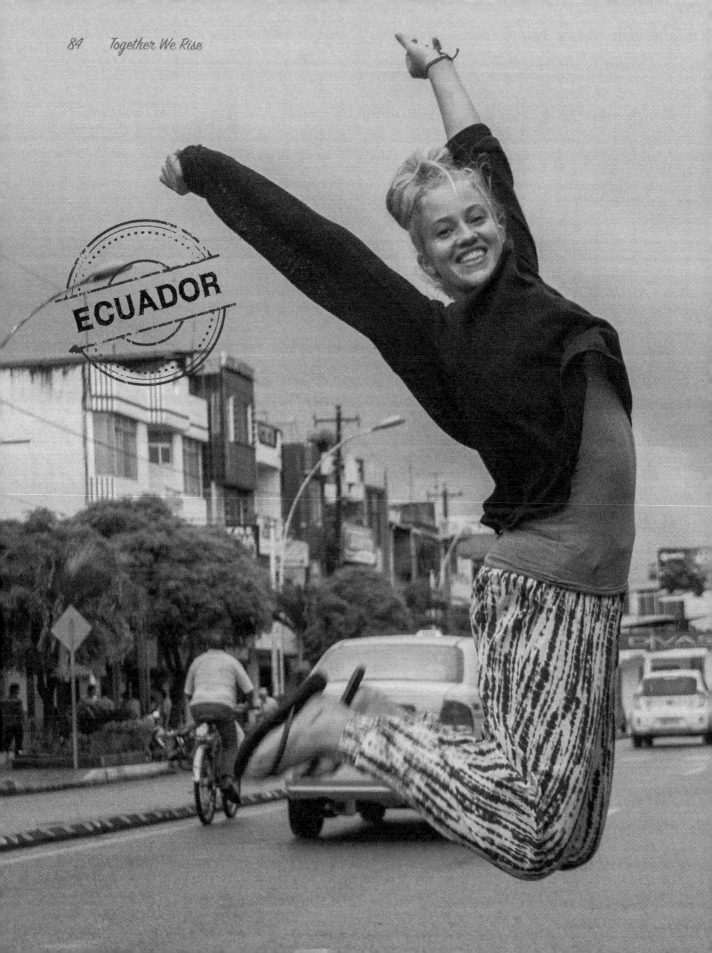

ECUADOR

"Right now, I'm thankful for being able to travel. I'm really lucky that I can do this. I'm thankful for all the people I'm able to meet, and that, despite the different backgrounds, we can enjoy and learn from one another. When you're traveling, you kind of open your eyes and see that you don't need all the material stuff that you have at home, essentially that less is more. I'm thankful to be able to experience that and to take that home so that I can live an easier, less complicated life."

Photos & Interview by Drew Hess and Maki Torres Fernandez (pictured below on the left and right)

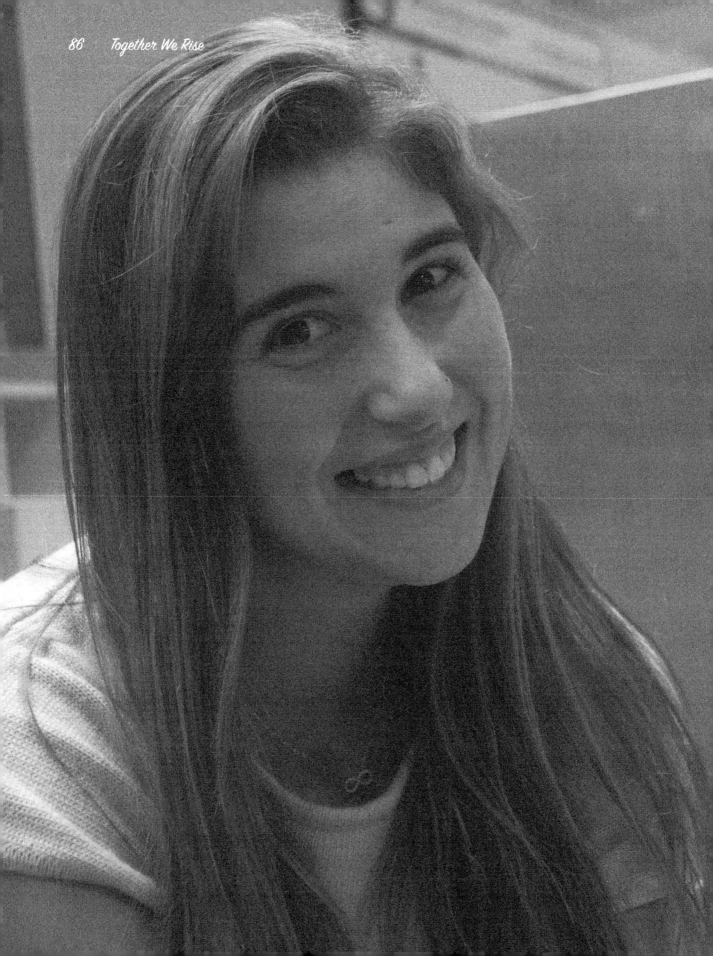

"*Three years ago, they diagnosed my mom with a brain tumor. She was incapacitated in many respects for a long time. In January, they operated on her and there were some tough months following but, by luck, she is getting healthier. This experience has made our family come closer together and for this, I am very thankful. I am also grateful to be able to come back to Spain from Argentina after seven years away, and to still have my entire family. Now that my mom is better, I am able to come back to Bilbao to start my university studies. I'm planning to study physical therapy. My experience with my mom has helped me make this decision. We spent a lot of time in a physical rehabilitation clinic during her recovery. While I was there, I saw a lot of small kids who couldn't live the life they'd imagined because their bodies wouldn't allow them. If this episode hadn't happened to my mom, I would have probably studied physical education. But what happened to her opened my mind and made me want to study this. I think the thing that helped my mom most in her fight against this illness was to see the family unified, together, and one supporting the other. It was a difficult moment for her and for us as well, but it was my mom who had to fight and do everything. Having a tight, supportive family is what helped her most.*"

Photo & Interview by Drew Hess

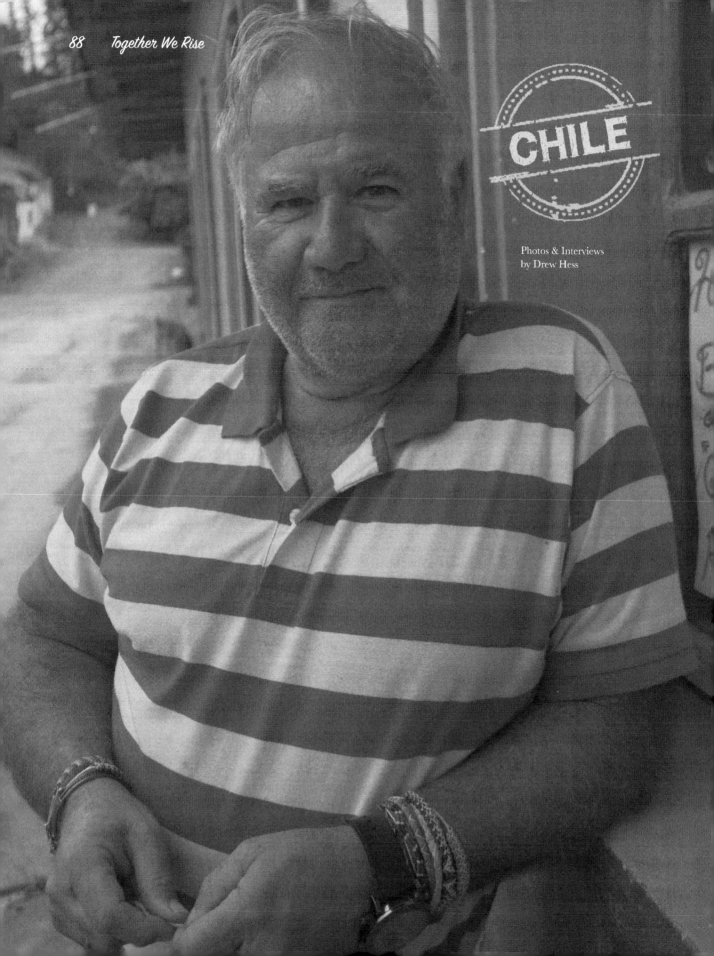

CHILE

Photos & Interviews
by Drew Hess

"I am thankful for my life, for Mi Jefe, My Boss — God. I confide that I have lived: I have a beautiful family in my country (Chile), and I wander the world with good people finding me every day. I believe the manner to know beauty, nature, and a country is through its people. Each person has a unique identity, unrepeatable. In all of the world and its green pastures, trees grow to the heavens. In the same way, around the world, each person is different. This sustains me tremendously to continue living."

JAMES FRANCO!

"I'm grateful I get to pursue a higher education."

(Interviewed in a coffee shop near Yale University)

Photo & Interview
by Corey Hudson

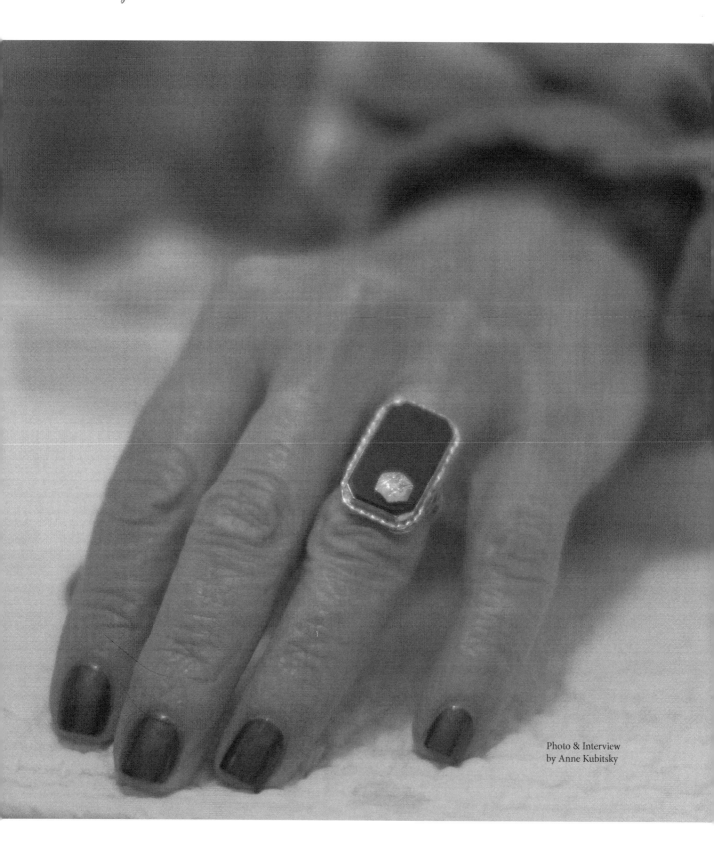

Photo & Interview
by Anne Kubitsky

*"It was a tumultuous relationship, but I was passionately in love.
Finally (after almost two years), I got my diamond. I was elated.
But within a month, We got into a fight one night over some jealousy
stuff and I ended up taking off my engagement ring and throwing it at
him. He grabbed it, and that was it. He wasn't giving it back. I was
hysterical at work the next day. Suicide was about all I could think of.
I was calling hospitals, psychiatric clinics, and any place I could think
of. One of my customers was a Rabbi. I had sold him his car a couple
months before and he just happened to show up that day. He took one
look at me and said, 'Do you need to talk?' He sat and talked with me
for two and a half hours. An angel showed up for me that day.
I mean, what was he doing there on that particular day? It's just
amazing. My life has been such an incredible journey with so
many blessings along the way!"*

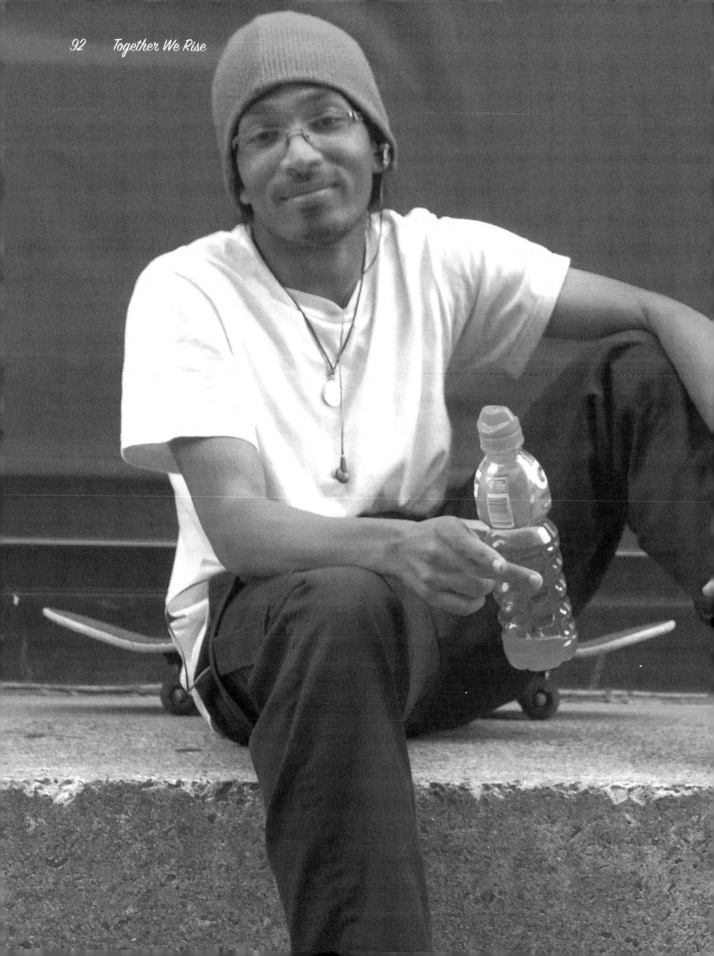

"If you think you are at rock bottom, there's still a choice and things could always get worse. The only way to go — once you hit the ground — is up from there. I've gone without food before and it's like, 'woah!'"

Photo & Interview by Corey Hudson

TESS MORRISON, MOTHER OF TWO, WRITES:

"The Dying Thing": that's what my mother called what was going on with her five years ago when I asked if she wanted to talk about it. She said, "You mean The Dying Thing? No, not really." We don't talk about that stuff, and yet, here it is. We are forced into dealing with it when it shows up, like when your friend never makes it home after a visit with you; Or the C word (C-A-N-C-E-R), is foisted on you or someone you love.

I had known my friend Maddie for fifteen years when she was diagnosed with stage four bladder cancer. Maddie was a feisty chick. She had planned to kick cancer's ass. Then she realized what her doctor was asking of her... and it didn't match her available strength or will. She asked her spirit guides and they told her she was being called early. She spoke to a specialist who she called "courageous" because he told her the truth: The medical world could do nothing to stop the progression of her disease. She was going to die in a month or two.

I spent the last Wednesdays of her life with Maddie. We spoke about things undone.

We spoke about who she thought she might have become and who she became instead. We spoke of her care. We spoke of suffering, pain, and tolerance. We spoke about simply receiving and how difficult it is. We spoke of small joys. We spoke about tea and hugs and telling stories, and the wonder of someone else brushing your hair — an echo of her grandmother's love.

We spoke about her memorial and she asked me to tell this story: Maddie had been given a beautiful box of homemade truffles a few weeks before. She usually didn't treat herself to such things. She asked, "Why the fancy box?" and the gift giver said it was because Maddie deserved the best. This was hard for Maddie to take in. As she sat with her tea and savored her truffles, she went into a vision. She found herself in a beautiful soft, secure nest in the arms of a tree. When she looked below her, she saw hundreds of smiling faces looking up enveloped in a warm, pink glow. It was a sea of faces that loved her. At that moment, her worst fear fell away: *Her fear of being unlovable simply fell away.* She told me this story through streaming tears of gratitude and a sense of peace I can only begin to comprehend. She asked me to share her thanks for all the prayers. She said, "I am

healed. I am whole. It worked. I know I am loved. It's all I ever wanted. Tell them."

Three days before she died, I met Maddie's best friend. They knew each other from before they could remember — pushed in strollers in tandem around their block. They were eachother's Person. I watched her say goodbye to her best friend of sixty-eight years. I walked Maddie's friend to her car where she held me, thanked me, and let her best friend go. I was utterly gutted. Grief is a visceral thing. It cannot be denied. It will have its way with you.

On our last Wednesday, I went to see Maddie and she died peacefully holding my hand. She felt safe enough with me to let go. I am going to say that again: *She felt safe enough with me to let go.* Death is a game changer for those who are left here. We are given a glimpse of purity, rawness, devastation, and grace. We are given the blinding clarity of what we truly have to offer: Our vulnerability, our joy, our thoughts, and our time. What we do with those gifts is the question. I am grateful to share, to honor, to witness, and to receive the gifts Maddie gave me.

Photo by Drew Hess.

Photo & Interview
by Corey Hudson

"I was a heavy kid into the arts and singing. It was my safe haven. I always sat alone at lunch until one day I went to sit with my friends and someone said, 'Why are you sitting here?' They said that there was no room for me. 'You're too fat.' They dumped my lunch tray and threw my book bag across the floor. My brother and his football buddies saw it and invited me to sit with them. I have learned that people do things like that because they are jealous, so I have kind of forgiven that. I had a kid once put a knife to my neck and threaten to kill me if I told the teachers about what he was doing to me. It's still hard to forgive him for that, but I think he must have been going through a lot at home and maybe wasn't receiving enough love and support from his mother and father. I can't really be angry at him for that.

"At one point I wanted to drop out or transfer because it was so bad. But then the anti-defamation league came to our school during violence prevention week. [Bullying] still goes on everywhere so it was nice to see how seriously everyone took it. I'm grateful they came when they did. It opened up my eyes to see that other kids were being bullied too. They asked me to speak in front of the school. It helped me push through high school and gain a lot of respect. I'm grateful for having a supportive family. My friends and family are what keep me going."

"We live on the second story of an apartment building. My neighbors are elderly and both have health issues. The gentleman is an amputee. He lost his leg because he's got severe diabetes. His partner — I'll call her Jane — is also elderly and has to work nights to provide for them. She has kyphosis of the back. They both have a hard time and I can see their daily struggles, yet they never ask for help. Their car was missing windows, the headlights were bashed in, and about a month ago, I saw Jane with the hood up, trying to fix the car. It was then that I decided that I would at least start with getting them a car. I set up a GoFundMe account and I got the word out just through Facebook. Within three weeks, we raised $906 from complete strangers located in England and America. They were donating $10… $30… $50… it was really beautiful to see. People were even making things and selling them on Etsy so that they could donate the proceeds. One man actually ate peanut butter and jelly sandwiches for a week so that the money he saved from his usual meals could go towards their fund. He ended up donating $50! I donated some money as well.

"Within a few weeks, we went to purchase a car which had been listed for more money than we had. When I told the guy what we were doing, he decided to sell it for the amount that we had - even though he had been offered more money for the car by someone else. When everything was ready, we put balloons on the car and a sign in the window and I knocked on Jane's door. She came downstairs, she saw the car, her hands went to her face, and the tears came. She said, 'This

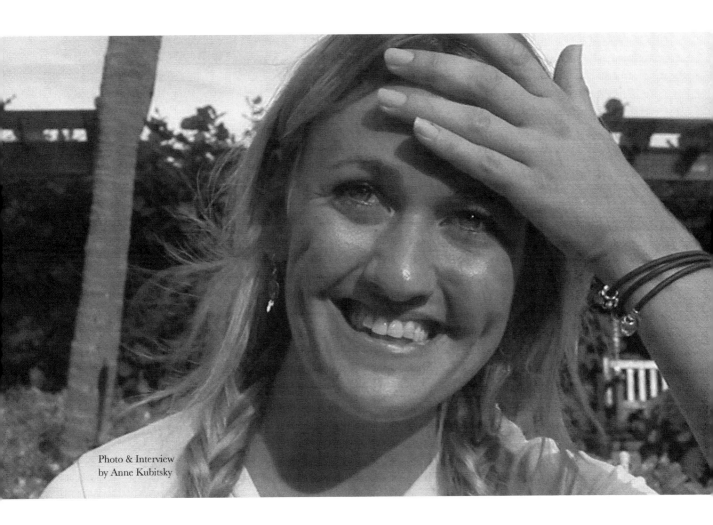

Photo & Interview
by Anne Kubitsky

is a miracle! I prayed for a miracle!' She told me that by Tuesday she wasn't
sure how she was going to get groceries. She was just overwhelmed and eternal-
ly grateful for the many strangers who came together to do this for her. I'm so
grateful that people put their trust in me and donated their money. If you see the
good is needed, you should help make it happen!'"

"I am grateful for tourists who come to our farm where we show some of the traditional techniques used to farm and produce food. It allows me to continue supporting my kids so they can go to school to achieve their dreams. My hope is that once he graduates, he can continue on to university. As for my other son, he wants to be a professional soccer player, and he's got his mind made up. I'm grateful to be able to help them both do whatever they want to do."

▶

AMAZON BASIN

Photos & Interview by
Drew Hess and Maki
Torres Fernandez

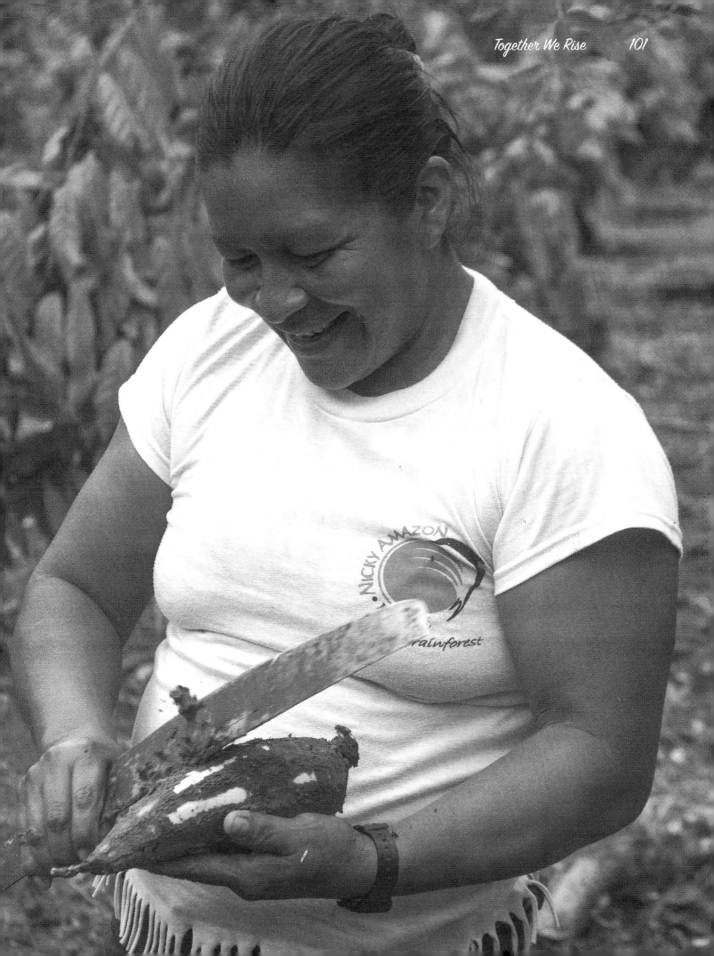

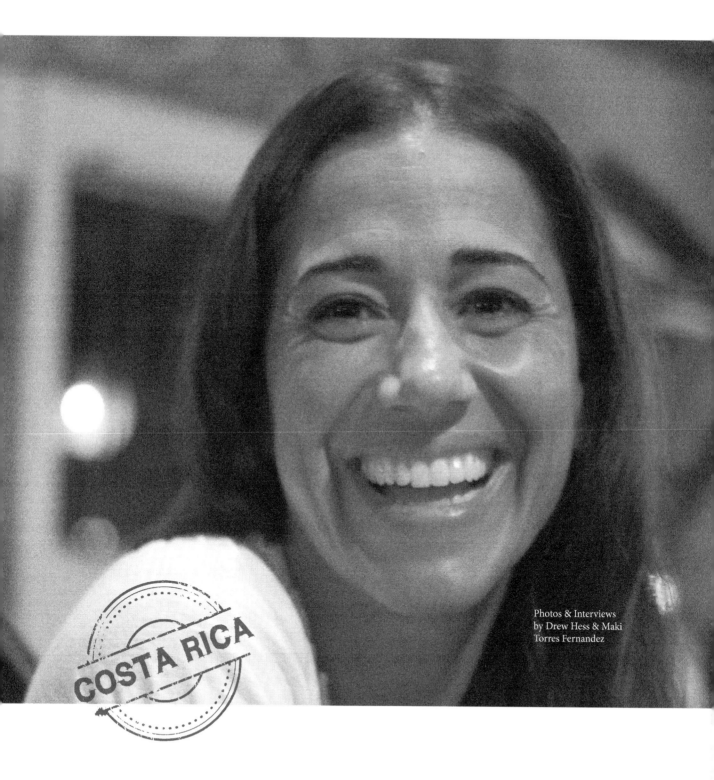

COSTA RICA

Photos & Interviews
by Drew Hess & Maki
Torres Fernandez

"I was married a long time ago, but my husband passed away. It was like Bam! One day, life changed. And it changed entirely: Job, friends, family. I had two options: (1) follow him and die, or (2) wake up. It's been six years since I chose to live. There is no other option. You have to persevere for your family and friends — the people who are supporting you. I decided to leave Spain and move to London. I packed a few things, just a carry on. I didn't know how to speak English or how much time I would spend there. A month? Fifteen days? I just needed to be far from home, in a place where nobody could watch me crying. It was there in London when I started to feel tranquility and peace. I believe at some point, something clicks and you just start feeling better. The overall experience was very positive. Going abroad helped me a lot. I am thankful for having a new life. My husband's death was tragic. People ask me if I was mad at him. Even today, I can't be mad at him because I think he gave me a new life, and a second chance."

"Travel like this opens your eyes to how many things we have to be grateful for about the hand we were dealt."

CHRIS O'BRIEN, COLLEGE STUDENT, WRITES:

I am grateful to be alive. On July 27th, 2011 I became paralyzed from the neck down.

While on vacation in Rhode Island, I dove into the ocean, hitting a sandbar. Immediately I knew something was wrong. I was floating in the water, face down, and had a numbing sensation throughout my body. My first instinct was to roll over, but I couldn't. I opened my eyes and saw my arms — they were just floating there motionless. Being a competitive swimmer, I was lucky enough to be able to hold my breath for a long time. Out of nowhere, my friends and others who saw me floating from the beach flipped me onto my back. I was carried onto the beach and driven to a small hospital on the island. From there, I was airlifted to Rhode Island Hospital where I underwent surgery to repair the break in my neck.

I am grateful for my family and friends.

After getting to the hospital, I began to learn about the severity of the accident. I had no motion in my arms or legs and could barely shrug my shoulders. I am not quite sure how to explain it, but I knew I would be okay and that this situation was something that I would overcome. Since the day of the accident I have been participating in intensive physical therapy all over the country in order to regain as much function as possible and to be able to go back to a normal life. While doing so, my family and friends have been there pushing and encouraging me every step of the way. I am very grateful for this huge support team which has kept me from ever doubting whether I would make it through all of this.

Of course not every day is easy and there is nothing wrong with that. Moving on can be tough, but it's a must. It's okay to feel bad about your own situation for five minutes a day, but any more than that is wasting your day. You shouldn't ask, "What if?" or "Why me?" Instead, use your time to help somebody else or just be present by living in the moment.

CONNECT ON FACEBOOK:
"Chris O'Brien's Determination Page"

Photo Courtesy of Carrie O'Brien

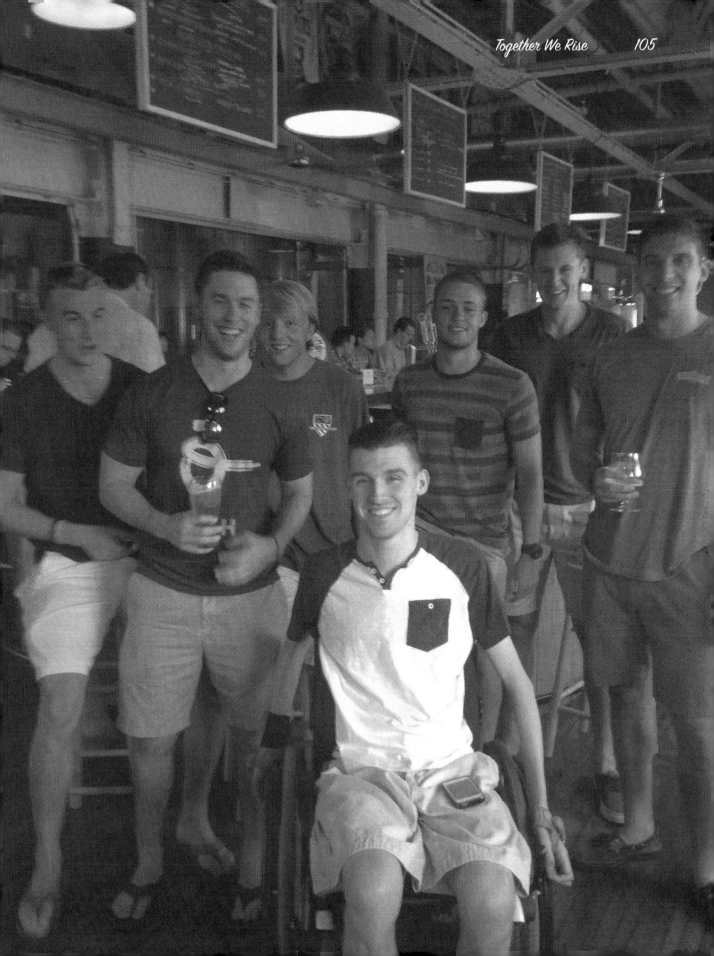

"I had to navigate in a canoe, paddling for an hour and half to get to school. I had to get up at 5:30 am in order to eat breakfast and arrive to school on time. There was rain every day... and I sometimes would arrive to school soaking wet, with wet notebooks. It was difficult [and] I had to fight for everything. But from there, it advanced. At times, one would wonder why we would undertake such a struggle for ourselves and for our families. But then one realizes that, little by little, you're growing and developing. I'm grateful for my family for supporting me... that I am here in this tour company... for the tranquility and peace... and to not have much suffering like I had before. Life is a little easier than before, and I feel thankful for having gone through everything."

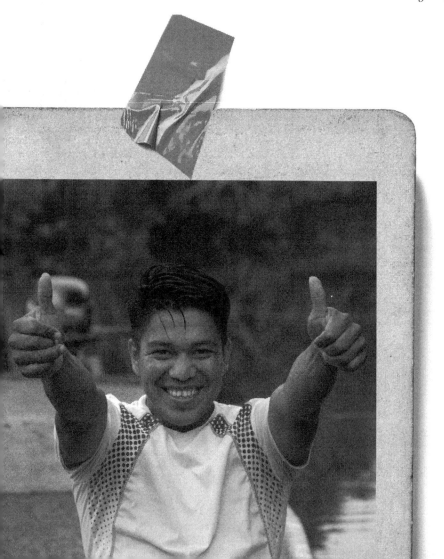

◀ *"I'm thankful that we have developed jobs... because work dignifies a man."*

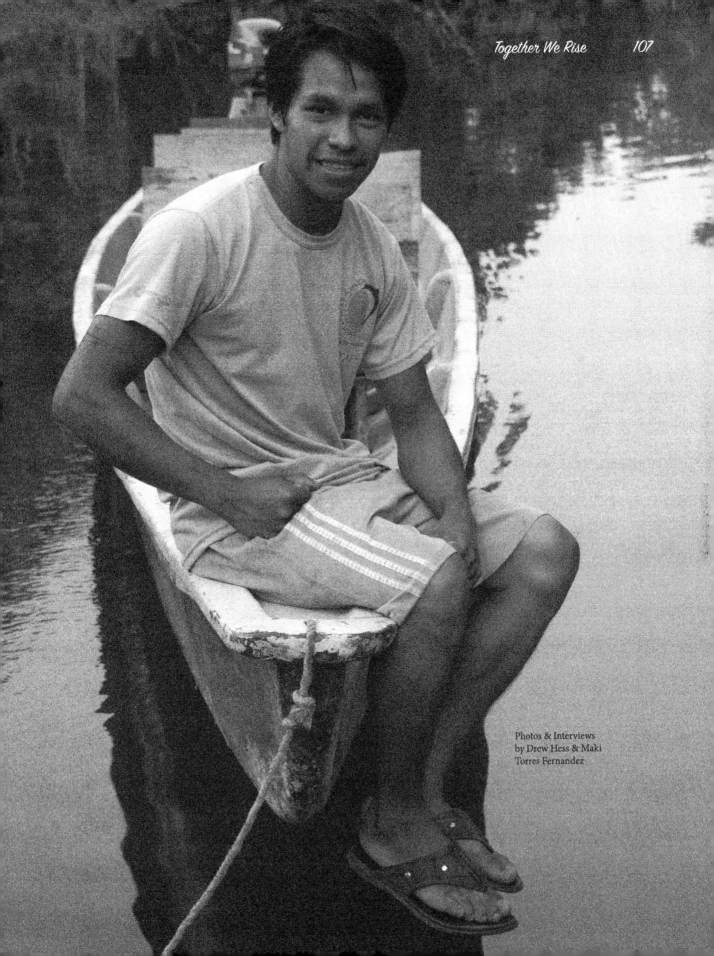

Photos & Interviews
by Drew Hess & Maki
Torres Fernandez

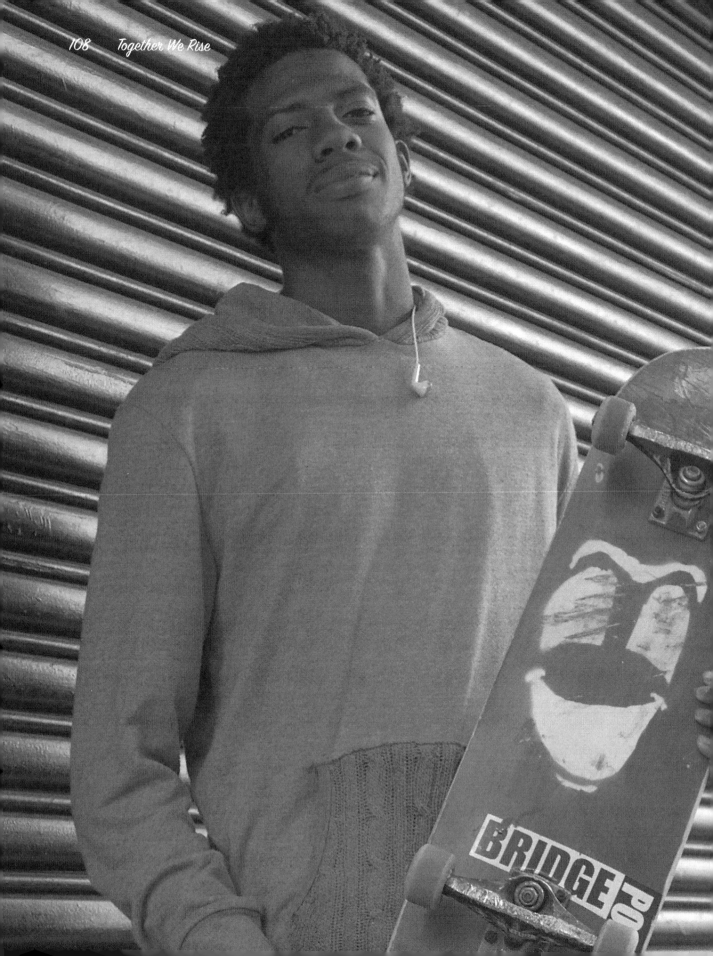

"I'm grateful for my friend who gave me my first skateboard which lead me to create my own skateboard company. I'm grateful for waking up another day, that there's music in the world, and for my parents who raised me to be the man that I am. My mom died last year. I was sixteen. After she passed, I started my own company. I try to push myself to my limits in everything I do. Even though she wasn't here to see me graduate... I'm just grateful that she was in my life."

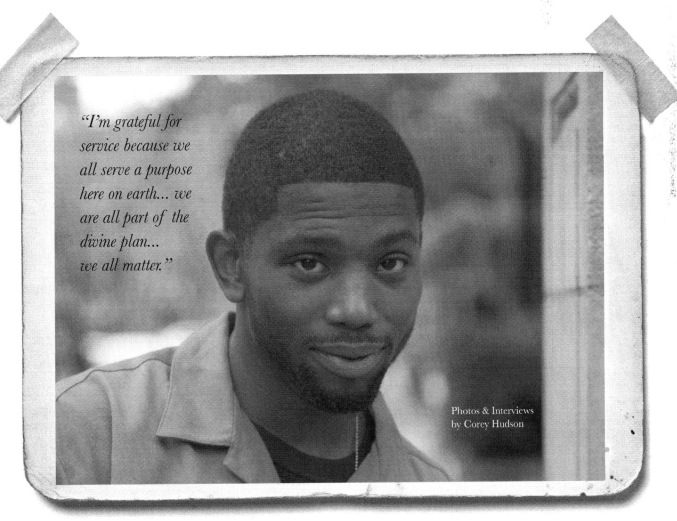

"I'm grateful for service because we all serve a purpose here on earth... we are all part of the divine plan... we all matter."

Photos & Interviews
by Corey Hudson

"I am grateful for my health, which allows to me to climb mountains and for the time that we've been given. My uncles and my family have supported me in pursuing my dreams even though the mountains are dangerous and they don't want us to lose our lives."

Photo & Interview by Drew Hess

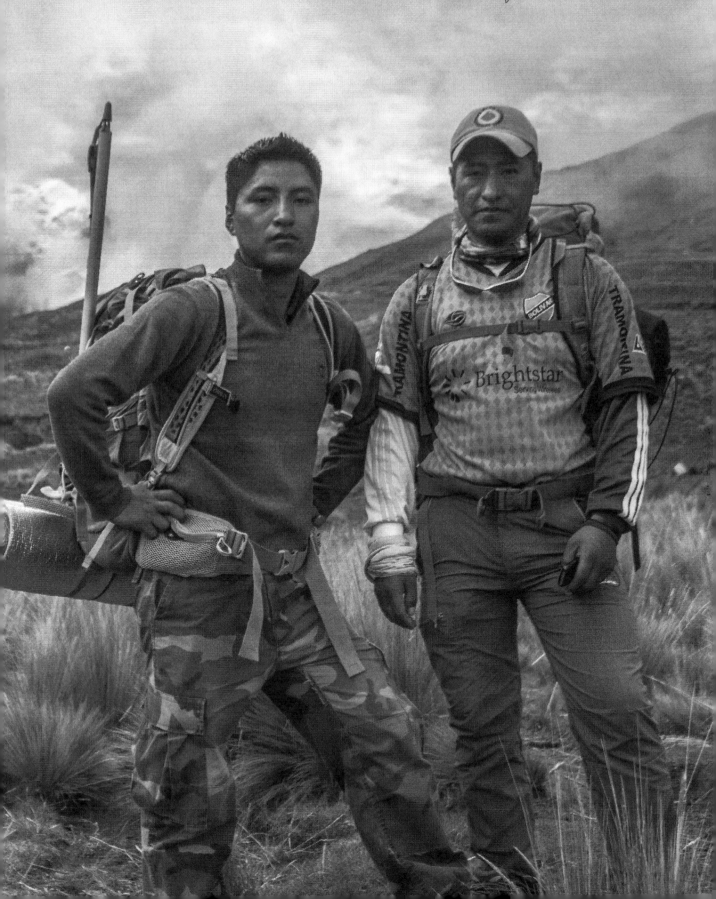

Interview by Anne Kubitsky;
Photo by Corey Hudson

"*The day of the Boston Marathon Bombing, we had tickets to the Red Sox Game. Our plan going into the day was to get to the stadium early so that we could get a drink at Lucky Strike because my boyfriend's friend worked there and we always saw him when we went to games. After the game, we planned to go straight to the finish line so that we could get as close as possible to the runners. But the morning of the marathon, we actually couldn't find the Red Sox tickets. We couldn't find them anywhere! When we tried to print them out again, the printer got jammed so we had to go to Staples instead. While we were at Staples, my boyfriend got sick and a lot of really bizarre things happened that prevented us from visiting Lucky Strike before the game. Pressed for time, we decided to see his roommate after the game, which is why we were at Lucky Strike — not the finish line — when the bombs went off. Because of this, I never get upset when plans don't work out because I believe that sometimes we are protected in ways we don't even understand.*"

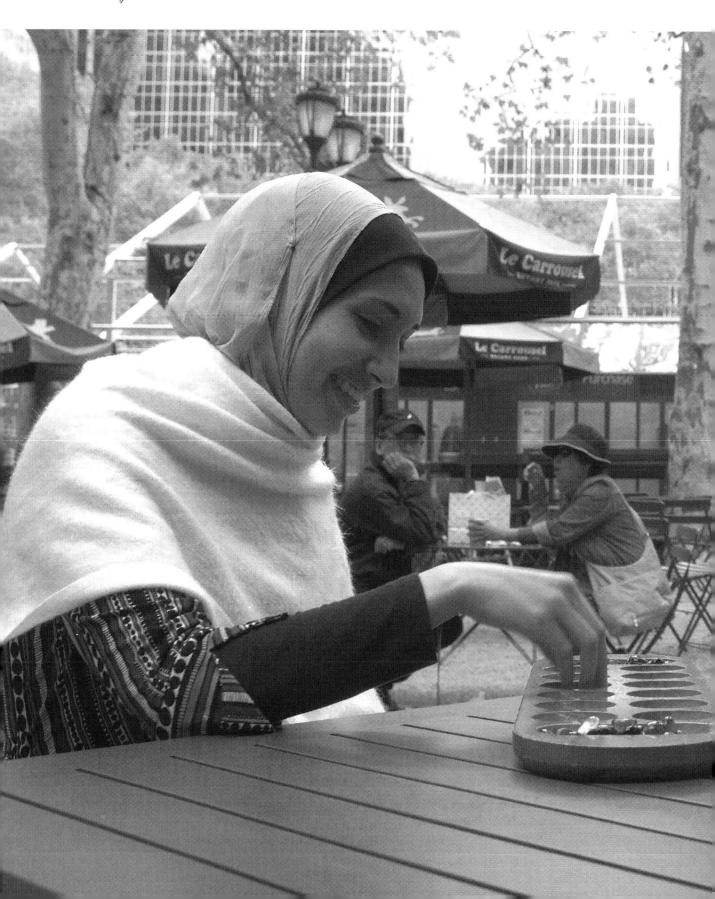

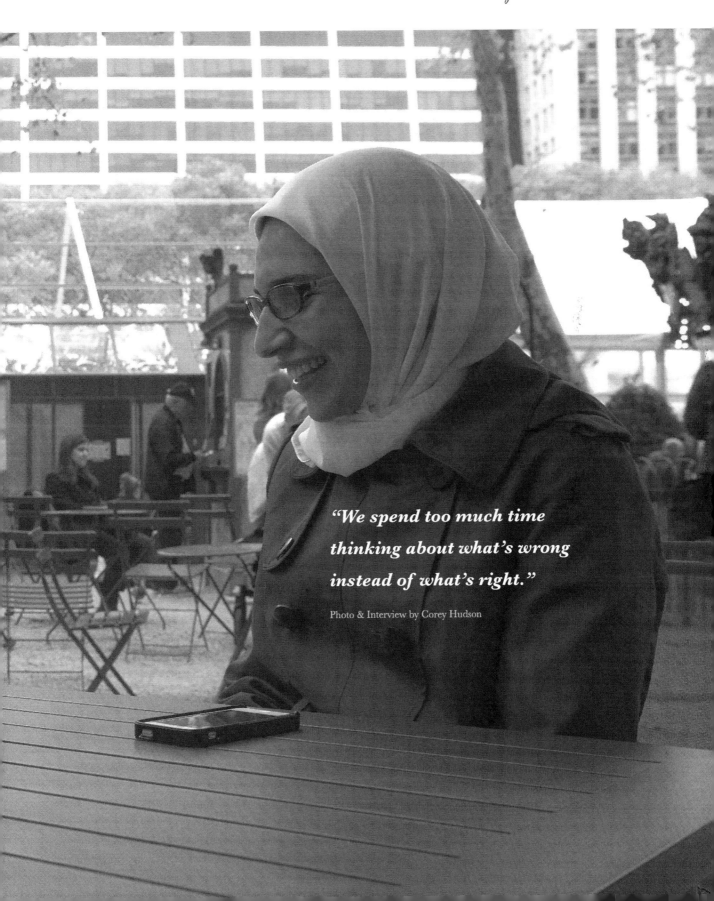

"We spend too much time thinking about what's wrong instead of what's right."

Photo & Interview by Corey Hudson

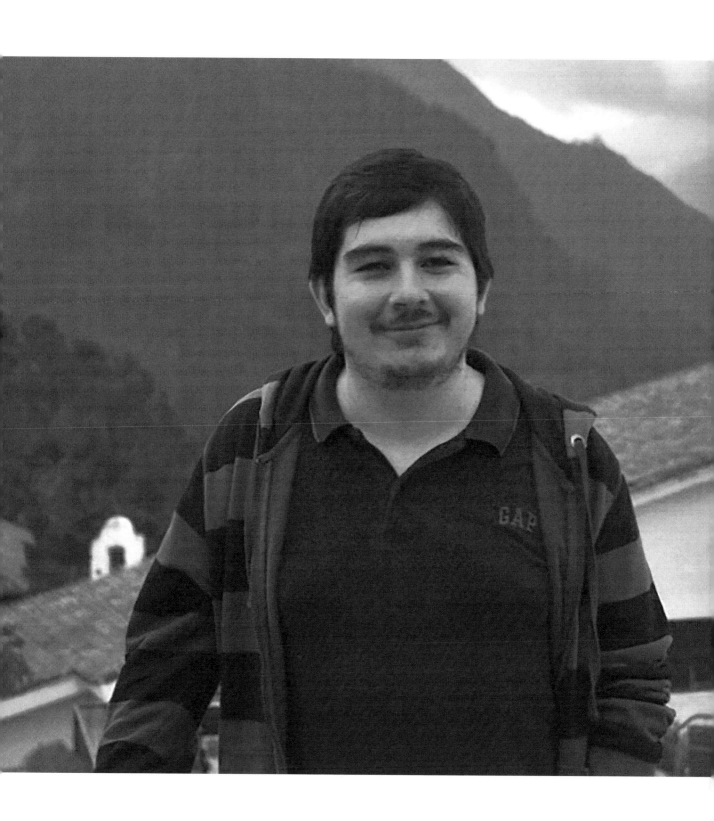

"*Many of us live simple and ordinary lives, almost boring, but not bad. Not everybody can make a movie of their life, but even still, there are plenty of happy moments and good memories, even in the most boring life story. It is time to stop telling people that they need a Hollywood life. It is a lot of pressure. With a regular life, emotional and physical health is enough and more than that: It is a gift from the cosmos that we cannot dismiss.*"

Photo & Interview by Maki Torres Fernandez

NOTE: The landscape photos on the following pages are courtesy of Drew Hess.

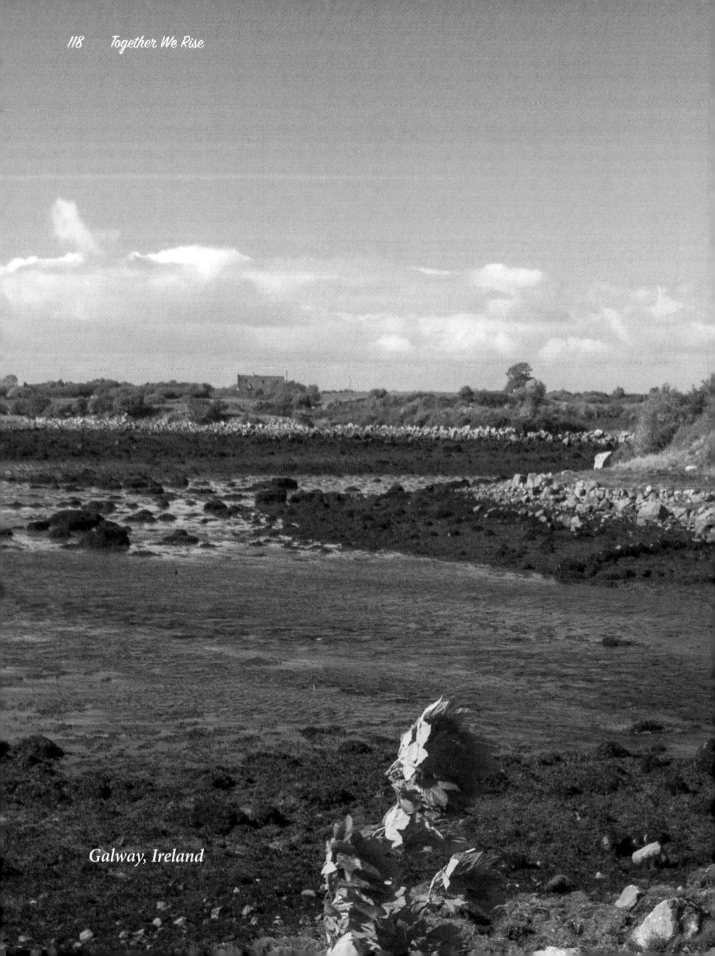

Galway, Ireland

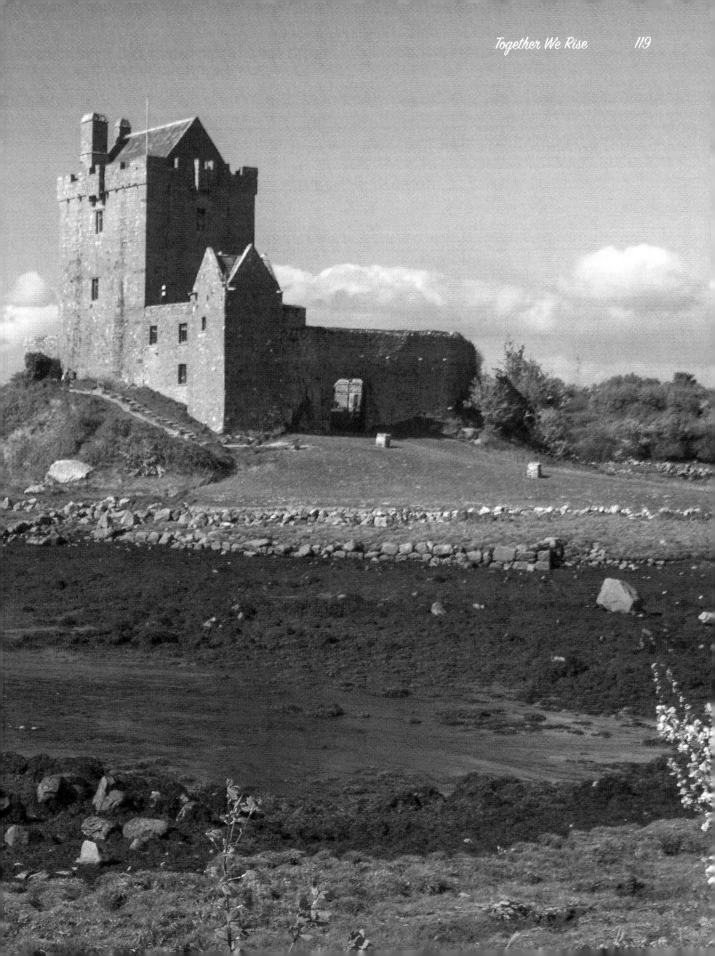

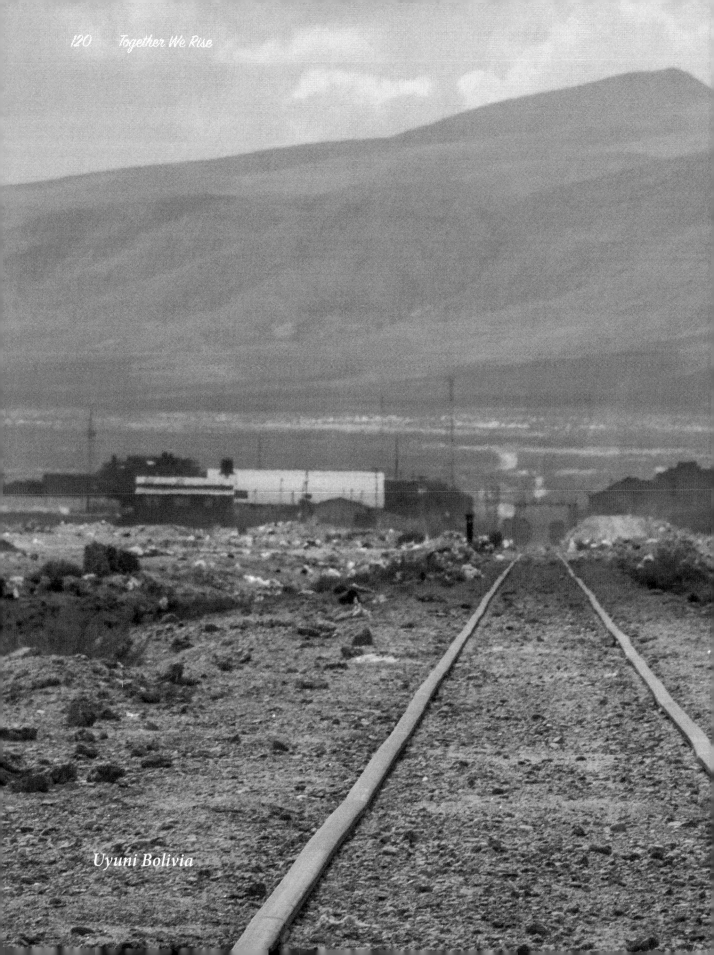

Uyuni Bolivia

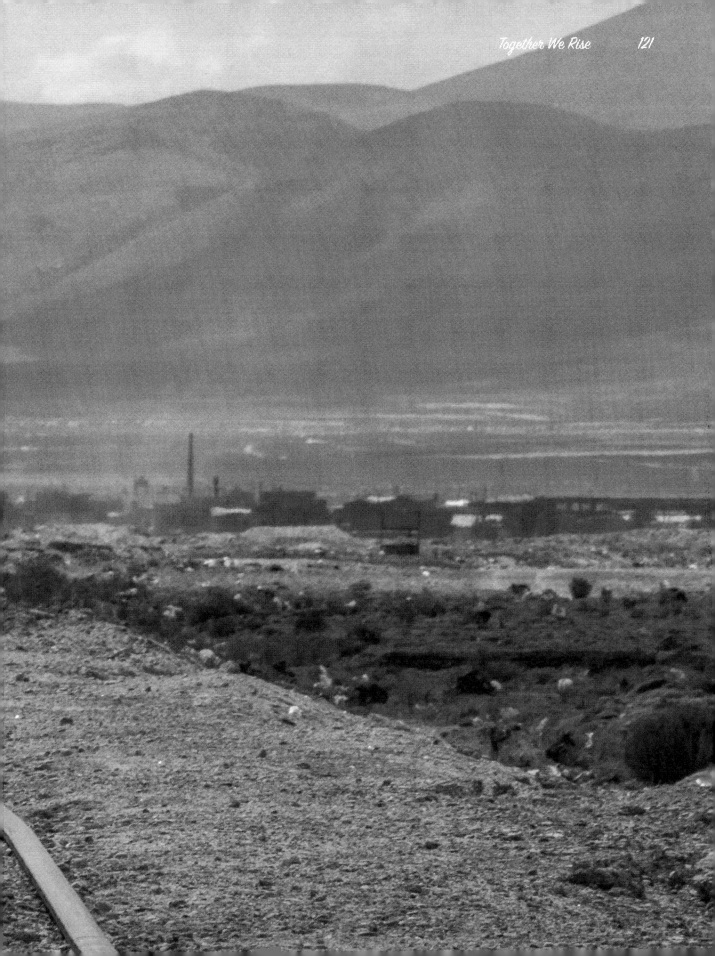

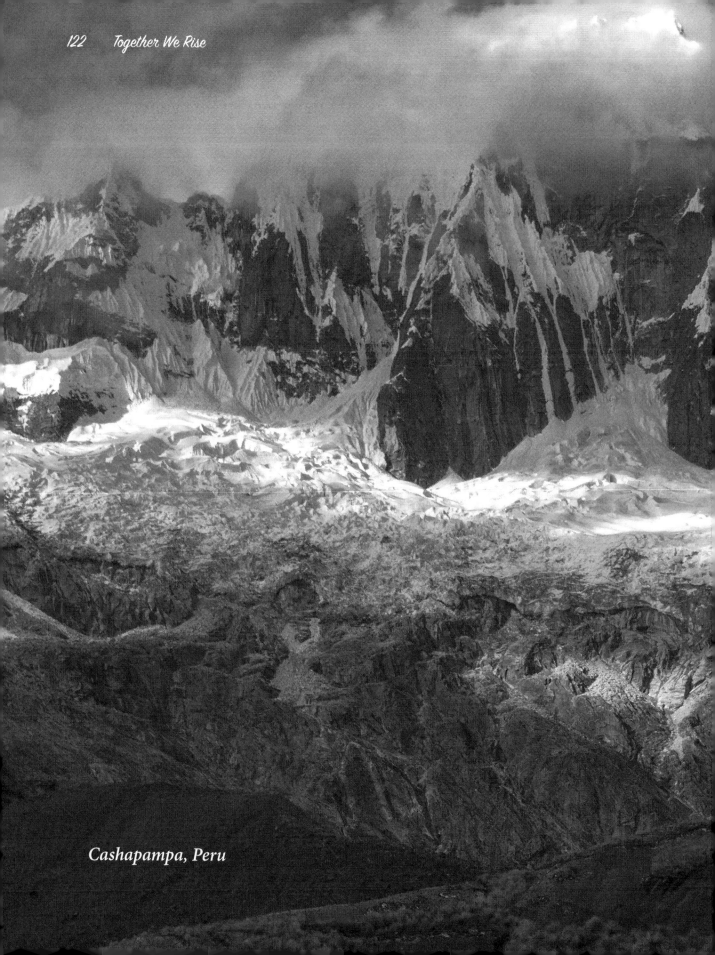

Cashapampa, Peru

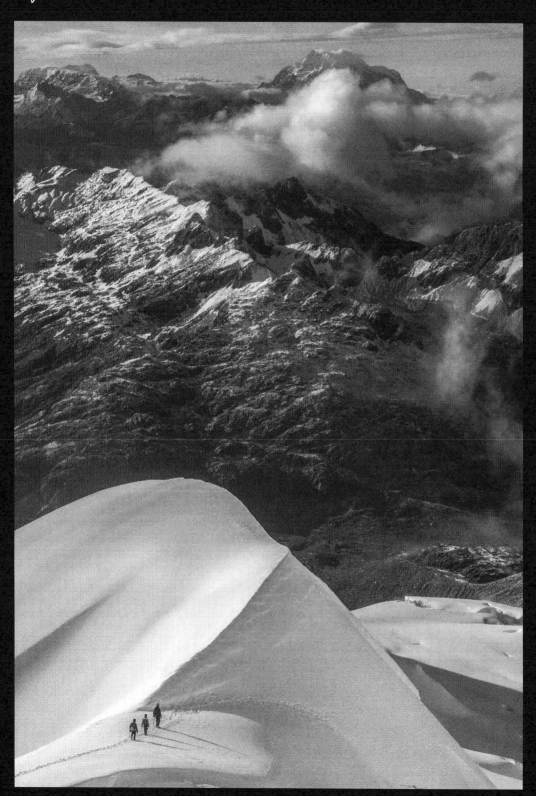

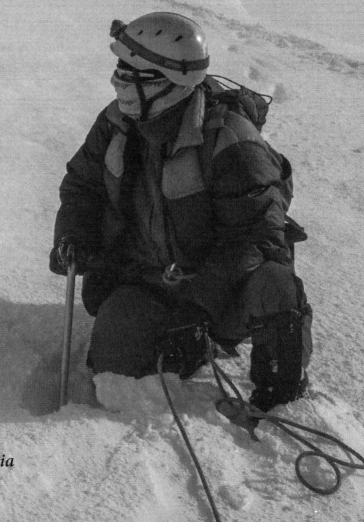

Huayna Potosi Mountain, Bolivia

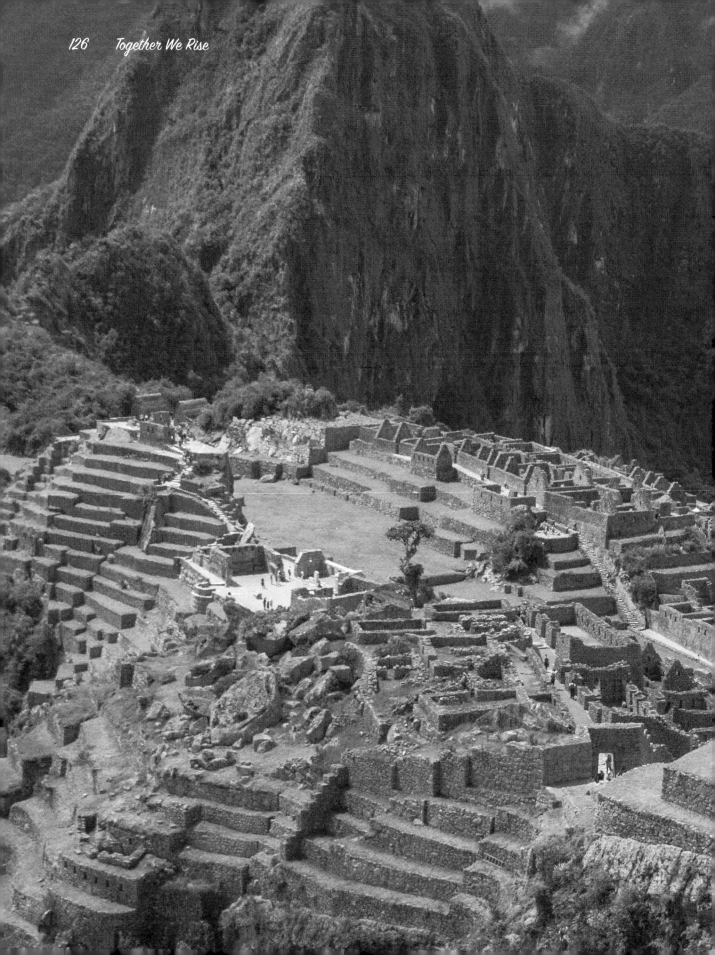

"No matter where we go, as we look around us, we are all the same. Go forth. Look for the good in your world."

- Drew Hess

Machu Picchu, Peru

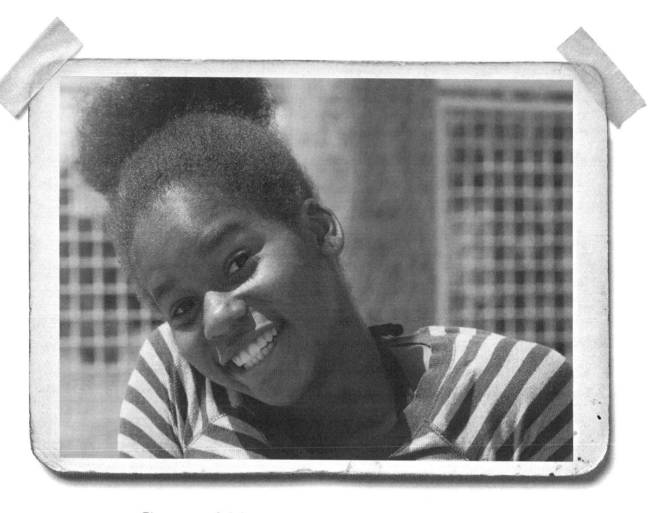

*I'm grateful because no one ever gave up on me
no matter how bad things got."*

TOGETHER WE RISE

www.lookforthegoodproject.org